HOW TO DRAW YOUR OWN
GRAPHIC NOVEL

ARCTURUS

ARCTURUS

This edition published in 2011 by Arcturus Publishing Limited
26/27 Bickels Yard, 151–153 Bermondsey Street,
London SE1 3HA

Author and illustrator: Frank Lee
Editor: Kate Overy
Art Director: Peter Ridley
Designer: Andrew Easton

ISBN: 978-1-84837-837-7
CH001753EN
Supplier 13, Date 0911, Print run 818

Printed in China

CONTENTS

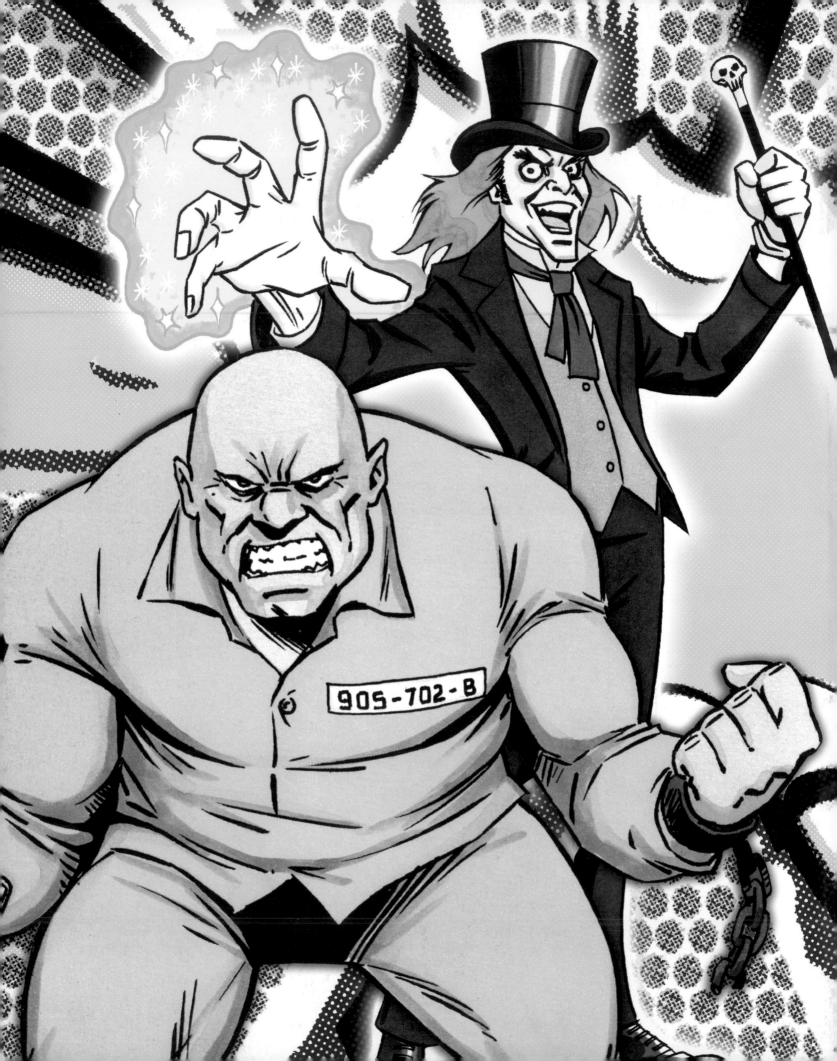

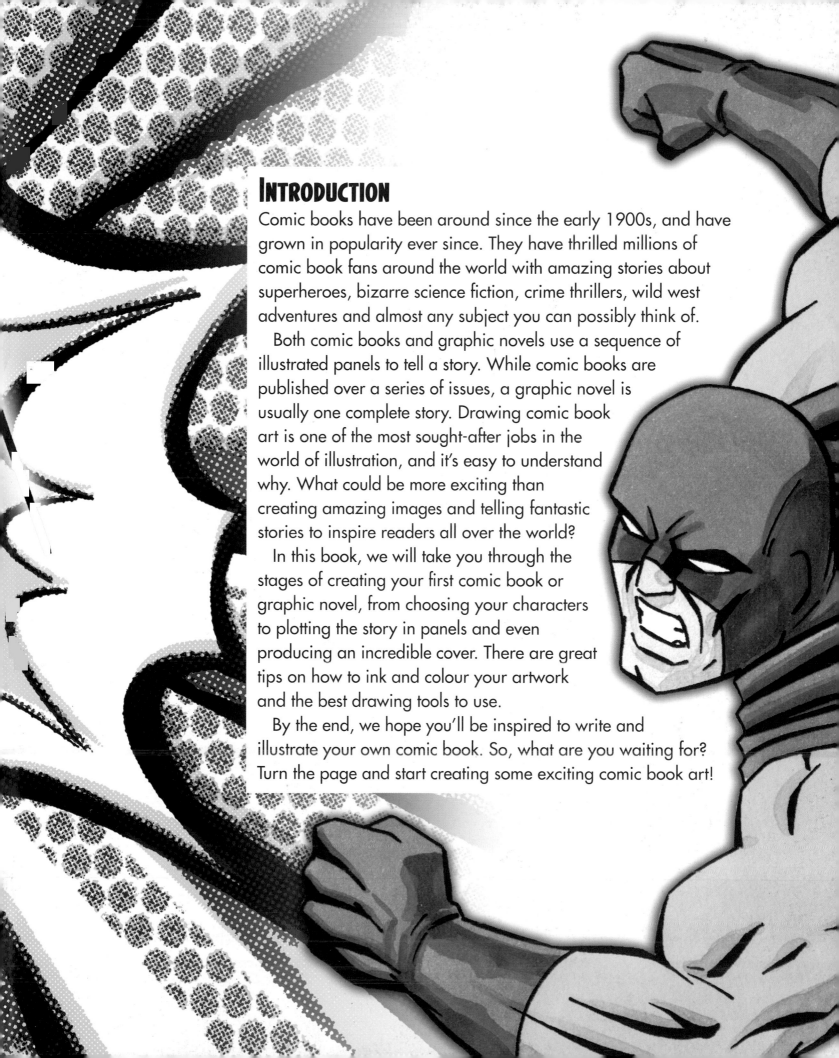

INTRODUCTION

Comic books have been around since the early 1900s, and have grown in popularity ever since. They have thrilled millions of comic book fans around the world with amazing stories about superheroes, bizarre science fiction, crime thrillers, wild west adventures and almost any subject you can possibly think of.

Both comic books and graphic novels use a sequence of illustrated panels to tell a story. While comic books are published over a series of issues, a graphic novel is usually one complete story. Drawing comic book art is one of the most sought-after jobs in the world of illustration, and it's easy to understand why. What could be more exciting than creating amazing images and telling fantastic stories to inspire readers all over the world?

In this book, we will take you through the stages of creating your first comic book or graphic novel, from choosing your characters to plotting the story in panels and even producing an incredible cover. There are great tips on how to ink and colour your artwork and the best drawing tools to use.

By the end, we hope you'll be inspired to write and illustrate your own comic book. So, what are you waiting for? Turn the page and start creating some exciting comic book art!

DRAWING TOOLS

Let's start with the essentials — the tools of the trade. Without them, there will be no cool pictures in your comic book!

LAYOUT PAPER

Artists, both as professionals and as students, rarely produce their first practice sketches on their best quality art paper. It's a good idea to buy some inexpensive plain A4 or A3 paper (whichever you prefer) from a stationery shop for all of your practice sketches. Go for the least expensive kind.

Most professional illustrators use cheaper paper for basic layouts and practice sketches before they get round to the more serious task of producing a masterpiece on more costly material.

CARTRIDGE PAPER

This is heavy–duty, quality drawing paper, ideal for your final version. You don't have to buy the most expensive brand. Most decent art or craft shops stock their own brand or a student range and, unless you're thinking of turning professional, these will do fine.

WATERCOLOUR PAPER

This paper is made from 100 per cent cotton, and is much higher quality than wood–based papers. Most art shops stock a large range of weights and sizes. 250 g/m or 300 g/m are fine.

LINE ART PAPER

If you want to practise black and white ink drawing, line art paper enables you to produce a nice clear crisp line. You'll get better results than you would on cartridge paper as it has a much smoother surface.

CIRCLE TEMPLATE

This is very useful for drawing small circles.

FRENCH CURVES

These are available in a few shapes and sizes and are useful for drawing curves.

ERASER

There are three main types of eraser: rubber, plastic and putty. Try all three to see which kind you prefer.

PENCILS

It's best not to cut corners on quality here. Get a good range of graphite (lead) pencils ranging from soft (6B) to hard (6H).

Hard lead lasts longer and leaves less graphite on the paper. Soft lead leaves more lead on the paper and wears down more quickly. Every artist has their personal preference, but 2H pencils are a good medium range to start out with until you find your favourite.

Spend some time drawing with each weight of pencil and get used to their different qualities. Another good product to try is the clutch, or mechanical pencil. These are available in a range of lead thicknesses, 0.5mm being a good medium range. These pencils are very good for fine detail work.

BRUSHES

Some artists like to use a fine brush for inking linework. This takes a bit more practice and patience to master, but the results can be very satisfying. If you want to try your hand at brushwork, you will definitely need to get hold of some good quality sable brushes.

MARKERS

These are very versatile pens and, with practice, can give pleasing results.

PENS

There is a large range of good quality pens on the market these days and all will do a decent job of inking. It's important to experiment with different pens to determine which you find most comfortable.

You may find that you end up using a combination of pens to produce your finished piece of artwork. Remember to use a pen that has watertight ink if you want to colour your illustration with a watercolour or ink wash. It's quite a good idea to use one of these anyway. There's nothing worse than having your nicely inked drawing ruined by an accidental drop of water!

INKS

With the dawn of computers and digital illustration, materials such as inks have become a bit obscure, so you may have to look harder for these but most good art and craft shops should stock them.

DRAWING FIGURES: BASIC SHAPES

A simple, but very effective way of drawing human (or super-human!) figures is to draw a stick figure and then build on it using a selection of basic shapes such as cylinders, balls, cubes and spheres. Learning how to give 3-D form to simple shapes (like the ones below) is the secret to drawing life-like figures.

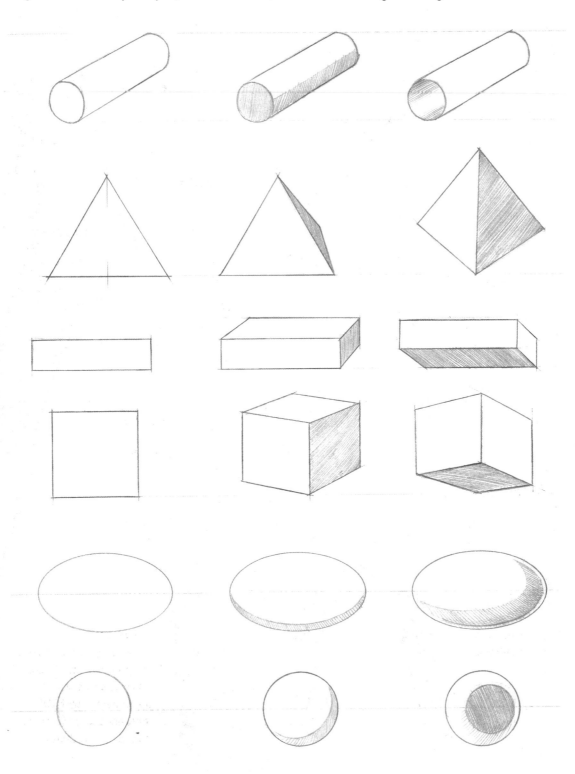

CONSTRUCTION SHAPES

Here is how to build the human figure by starting with a stick figure, then building on it using basic shapes. Whatever pose you want to draw your character in, once you have learnt this step-by-step technique, you'll have the skills you need to draw realistic-looking figures with ease.

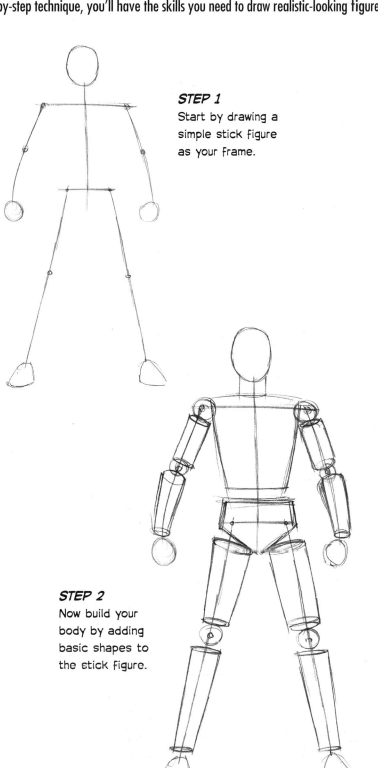

STEP 1
Start by drawing a simple stick figure as your frame.

STEP 2
Now build your body by adding basic shapes to the stick figure.

STEP 3
Draw around the shapes to produce your figure outline. Once you have established your character's body shape, you can add details.

FIGURE DRAWING: SIZE RATIOS

Comic books and graphic novels would be extremely boring if all the characters in the stories were the same size! Drawing figures of different shapes and sizes will make your story more interesting. Before you start drawing your comic book pages, try drawing a size chart to map out your characters' heights in relation to one another.

Artists often measure character height by the number of human heads it takes to make up their height. The average male human figure is generally considered to measure six and a half heads tall, but in comic books, the hero usually stands at eight and a half heads tall.

Study the height chart below. The third character along is eight heads tall and is a normal-looking tough guy. The extra height makes him look

9 Heads

8 Heads

7 Heads

6 Heads

5 Heads

4 Heads

3 Heads

2 Heads

1 Head

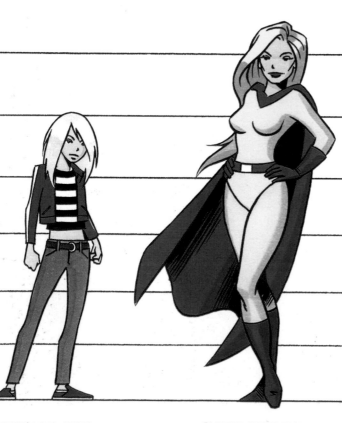

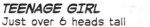

TEENAGE GIRL
Just over 6 heads tall

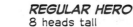

SUPERHEROINE
7.5 heads tall

REGULAR HERO
8 heads tall

more powerful. The warrior to the right of him stands eight-and-a-half heads tall, giving him true comic book hero status.

The teenage girl on the far left measures six-and-a-quarter heads tall. This is an exaggerated height for a girl in normal terms, but she's still tiny by comic book standards. The superheroine beside her is seven-and-a-half heads tall. This makes her taller than a normal man,

but she's still shorter than her male comic book counterparts. Superheroines are generally one head shorter than superheroes.

Our final character, the giant on the far right, defies the standard rules that apply to figure drawing. His ape-like frame is eleven heads tall, and his head is twice the size of the warrior's. When you create your own characters, don't be afraid to break the rules!

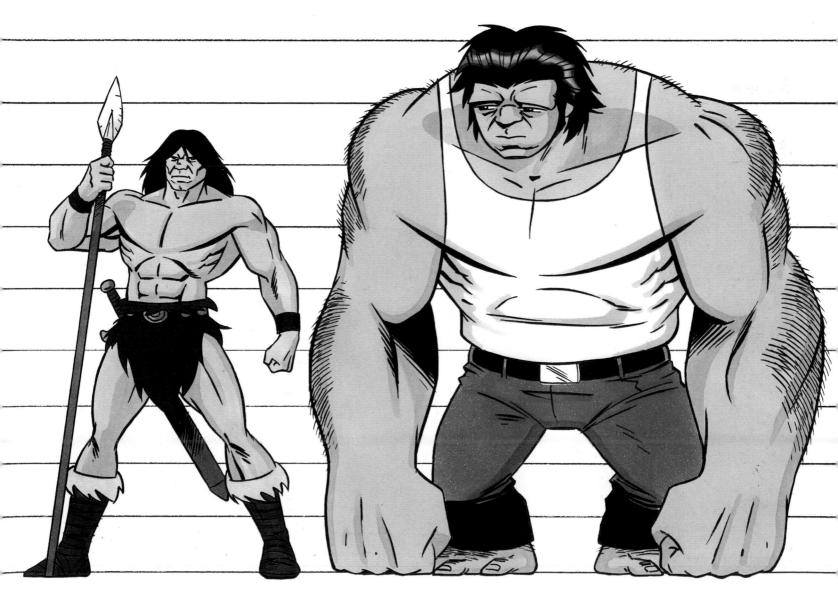

WARRIOR
8.5 heads tall

GIANT
11 heads tall

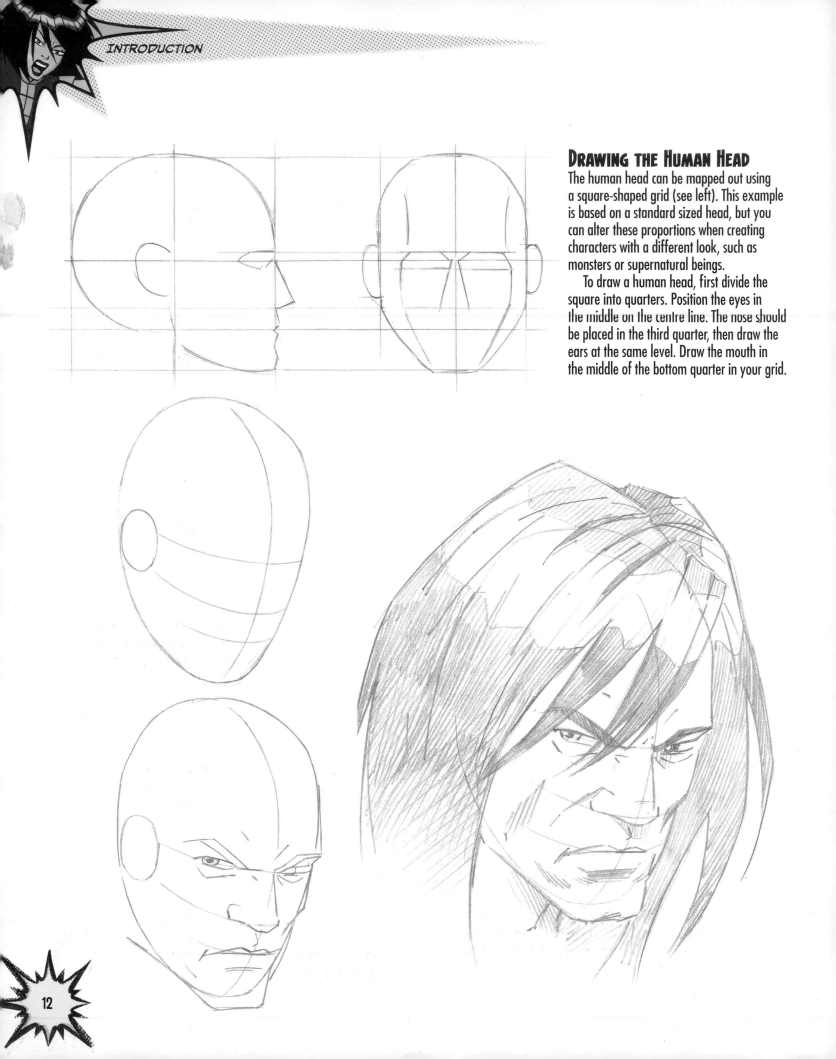

DRAWING THE HUMAN HEAD

The human head can be mapped out using a square-shaped grid (see left). This example is based on a standard sized head, but you can alter these proportions when creating characters with a different look, such as monsters or supernatural beings.

To draw a human head, first divide the square into quarters. Position the eyes in the middle on the centre line. The nose should be placed in the third quarter, then draw the ears at the same level. Draw the mouth in the middle of the bottom quarter in your grid.

PERSPECTIVE

Drawing superheroes and other exciting characters is a lot of fun, but it's only one part of the process of creating a comic book. You need to create a world for your characters to inhabit. To make your scenery realistic and believable, a basic knowledge of perspective is necessary.

VANISHING POINT AND HORIZON LINE

Study the diagram of a train track, below (Fig. 1). Notice how the rails get closer together the further they go into distance. The point where the lines join is called the vanishing point. The horizontal line in the distance is called the horizon line. The horizon line is the viewer's eye level.

FIG. 1

PLOTTING PERSPECTIVE

Let's take a simple cube (Fig. 2a) and look at how the rules of perspective apply.

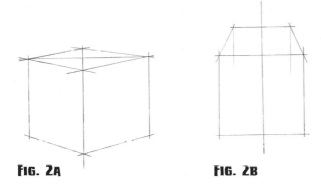

FIG. 2A **FIG. 2B**

Take the cube and turn it so we are looking at it straight-on (Fig. 2b). Draw a line down the middle. Notice that the two sides on the top appear to be drawing closer together towards the back.

If we continue these lines, they will eventually meet (Fig. 3). The point at which they meet determines the horizon line. This is called a one-point perspective because the lines meet at a single point (Fig. 4).

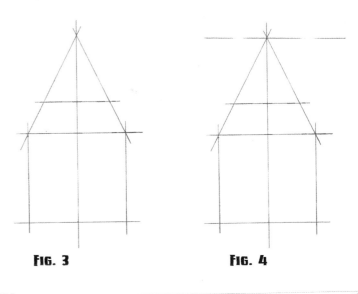

FIG. 3 **FIG. 4**

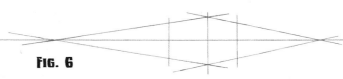

FIG. 5

When we turn the cube so we are looking directly at one of the corners, we get a two-point perspective (Fig. 5). This means there are two vanishing points.

FIG. 6

Here is the cube from above, with the horizon line cutting through its centre (Fig. 6). If we follow the converging lines to their ultimate meeting point, again, we get a two-point perspective.

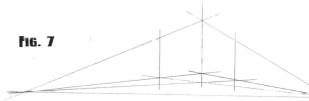

FIG. 7

The same applies if we view the cube from below (Fig. 7).

APPLYING PERSPECTIVE

Here are some examples of how to apply the rules of perspective to comic book panels. Even though it's tricky, it's important to try to get the perspective right in your comic book pages. To make your scenes look realistic, all of the elements in the foreground, background and centre of your page must be positioned correctly.

When you have multiple vanishing points, attach another sheet of paper to your drawing, so that you can continue the perspective lines off the page to get them just right.

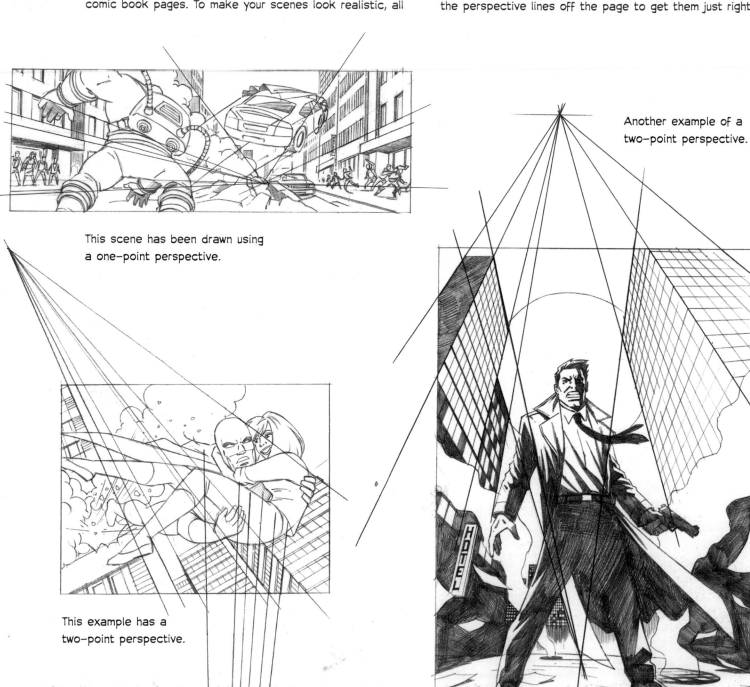

This scene has been drawn using a one-point perspective.

Another example of a two-point perspective.

This example has a two-point perspective.

CREATING HEROES

CHAPTER #1

The hero... champion of the people, righter of wrongs, protector, avenger and saviour. Who will you choose to play the starring role in your story? Will your hero be super-powered and bullet proof? Will they just be an ordinary guy or girl with the heart and bravery of a lion in the face of danger? In this chapter we'll show you lots of different types of character to help you decide what sort of hero you want to create.

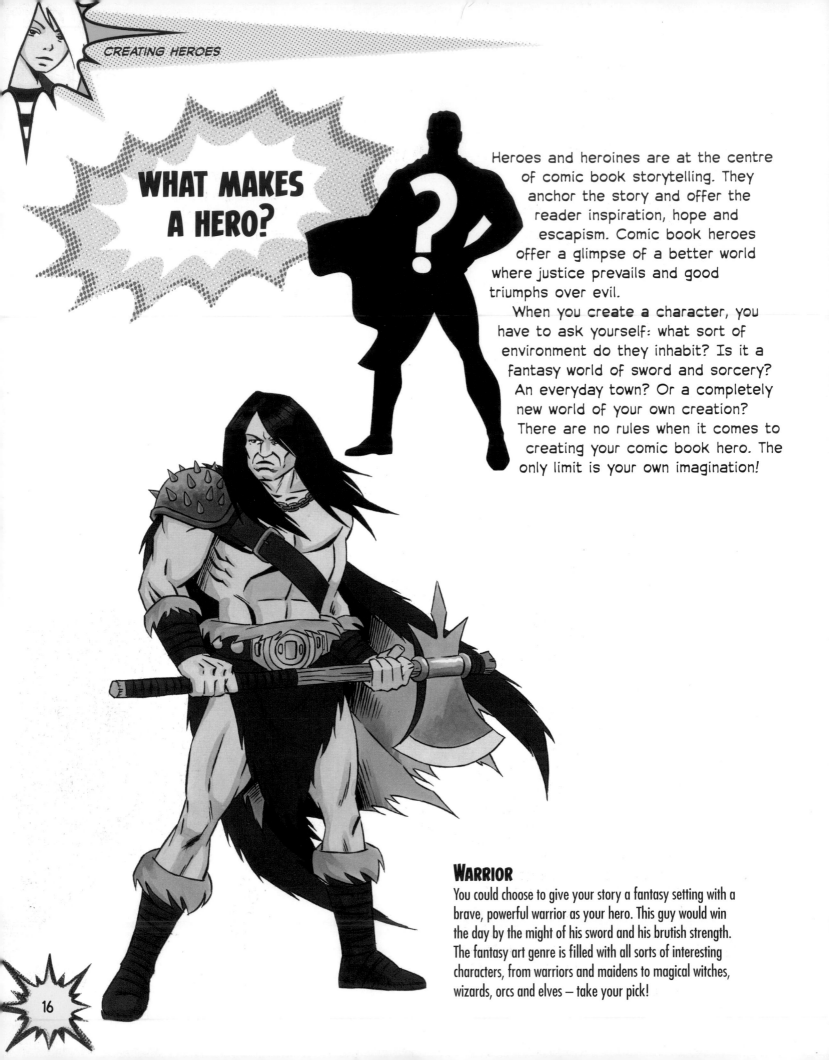

WHAT MAKES A HERO?

Heroes and heroines are at the centre of comic book storytelling. They anchor the story and offer the reader inspiration, hope and escapism. Comic book heroes offer a glimpse of a better world where justice prevails and good triumphs over evil.

When you create a character, you have to ask yourself: what sort of environment do they inhabit? Is it a fantasy world of sword and sorcery? An everyday town? Or a completely new world of your own creation? There are no rules when it comes to creating your comic book hero. The only limit is your own imagination!

WARRIOR

You could choose to give your story a fantasy setting with a brave, powerful warrior as your hero. This guy would win the day by the might of his sword and his brutish strength. The fantasy art genre is filled with all sorts of interesting characters, from warriors and maidens to magical witches, wizards, orcs and elves — take your pick!

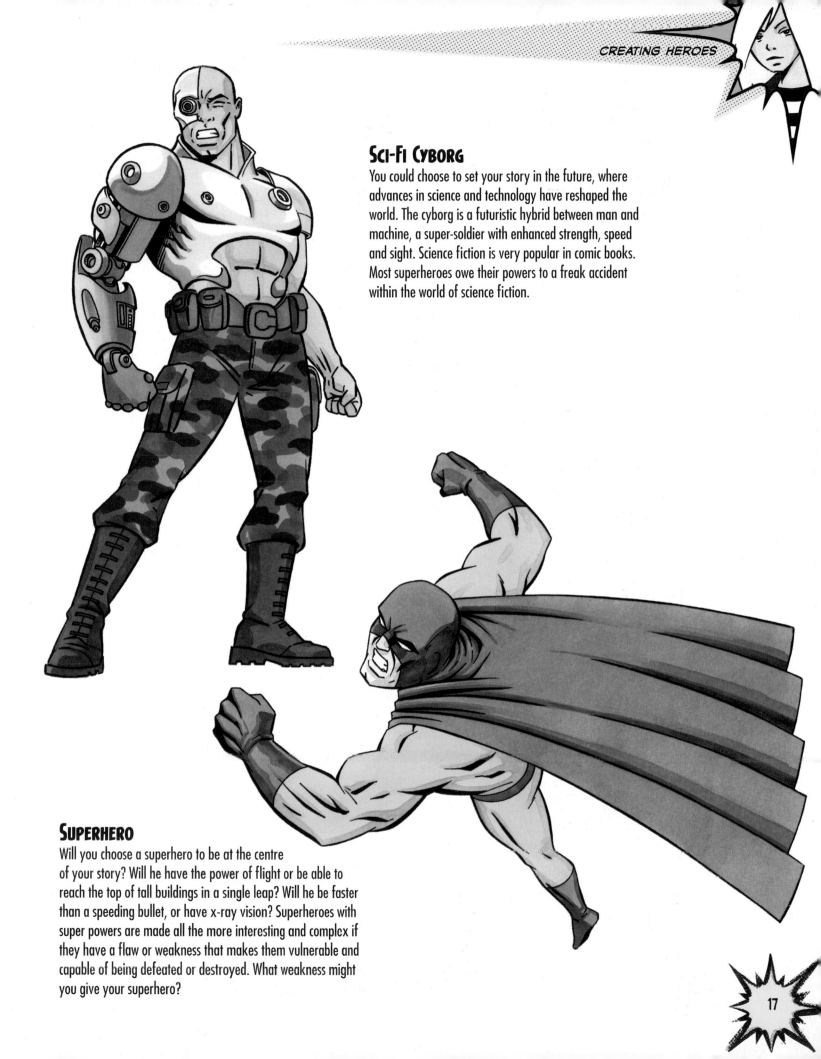

Sci-Fi Cyborg

You could choose to set your story in the future, where advances in science and technology have reshaped the world. The cyborg is a futuristic hybrid between man and machine, a super-soldier with enhanced strength, speed and sight. Science fiction is very popular in comic books. Most superheroes owe their powers to a freak accident within the world of science fiction.

Superhero

Will you choose a superhero to be at the centre of your story? Will he have the power of flight or be able to reach the top of tall buildings in a single leap? Will he be faster than a speeding bullet, or have x-ray vision? Superheroes with super powers are made all the more interesting and complex if they have a flaw or weakness that makes them vulnerable and capable of being defeated or destroyed. What weakness might you give your superhero?

17

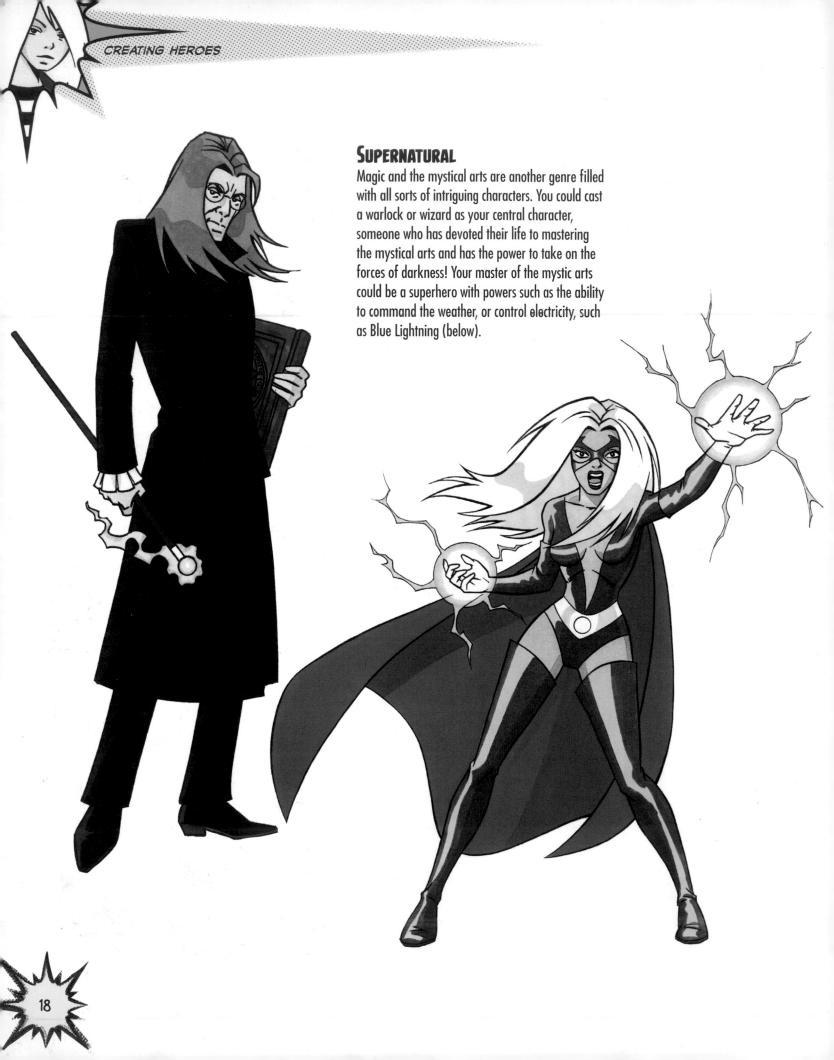

SUPERNATURAL

Magic and the mystical arts are another genre filled with all sorts of intriguing characters. You could cast a warlock or wizard as your central character, someone who has devoted their life to mastering the mystical arts and has the power to take on the forces of darkness! Your master of the mystic arts could be a superhero with powers such as the ability to command the weather, or control electricity, such as Blue Lightning (below).

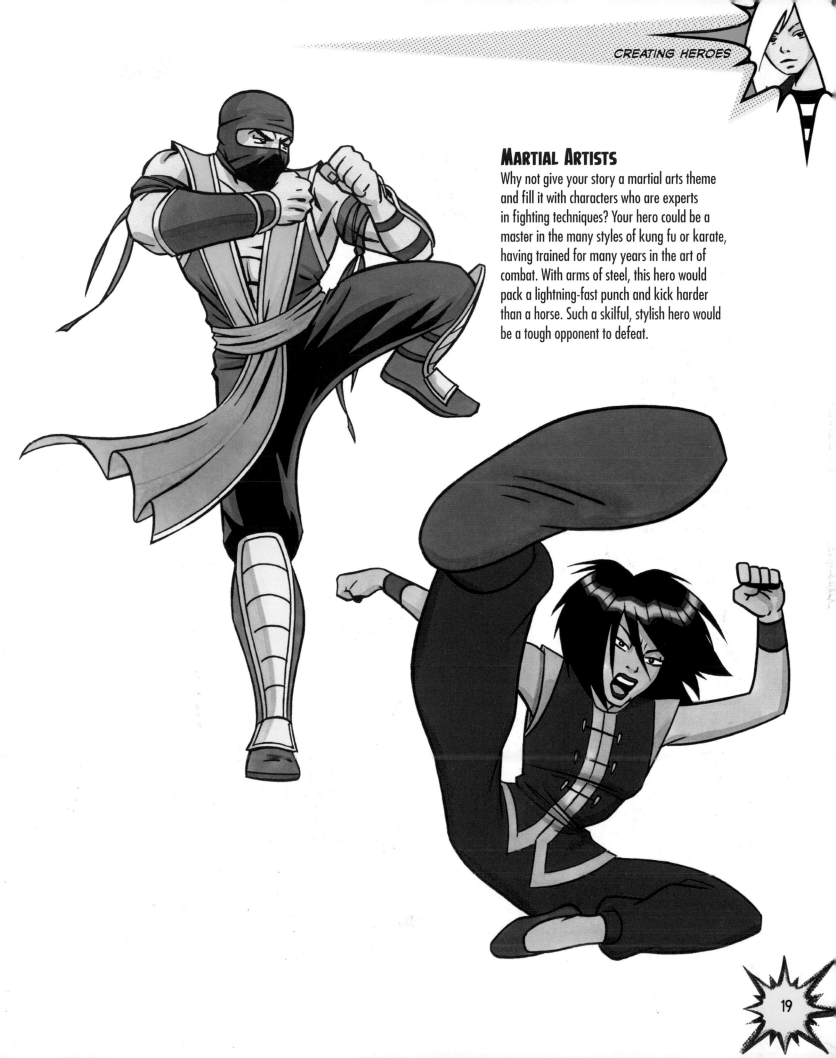

MARTIAL ARTISTS

Why not give your story a martial arts theme and fill it with characters who are experts in fighting techniques? Your hero could be a master in the many styles of kung fu or karate, having trained for many years in the art of combat. With arms of steel, this hero would pack a lightning-fast punch and kick harder than a horse. Such a skilful, stylish hero would be a tough opponent to defeat.

WESTERN

Yee-haw! You could choose to set your story in the pioneering days of America and include gunfights, horse chases and big, sweeping untamed landscapes. There have been many heroes of the Wild West. It's not just the villains who may wish to conceal their identity. Perhaps your hero is someone who leads a dual life, a character who blends in to the crowd and tries not to draw attention to himself, but by night wages war on the corrupt and evil.

ANTI-HERO

Perhaps your hero will be an anti-hero, a character out for nothing more than his own gain, whatever that might be. He could be a Robin Hood style character who steals only from the rich, but whether he gives to the poor — that's for you to decide… Or your hero could be a soldier of fortune — a mercenary whose skills are available to the highest bidder. Anti-heroes are more popular in comic books now, and the line between good and evil is becoming increasingly blurred.

UNASSUMING HERO

Not all heroes are muscle-bound with super powers. Some of the most captivating characters are just ordinary people who are thrown into an extraordinary situation. Some heroes possess nothing more than a fearless heart to stand tall against the forces of evil and the intelligence to outwit their enemies.

GOOD COP

Crime comics offer a gritty realism where tough, cynical cops dish out justice to even tougher criminals in cities that are overflowing with crime and corruption. Characters in this genre are often complex. The relationships and loyalties between cops and criminals are often intertwined, making it hard to know who to trust.

CREATING CHARACTERS

Over the next few pages you'll learn how to draw three different heroes. You could choose to adapt and develop one of these figures to create your own central character. Even if you want your hero to look very different, the step-by-step technique you'll learn can be applied to any figure. Once you have learnt the basic construction of a human form, you can build any character using the initial frame.

Example 1: Warrior

STEP 1

Establish the warrior's pose by drawing a matchstick figure, then add basic shapes to this frame. The warrior is strong and muscular, so we need to use bulky construction shapes.

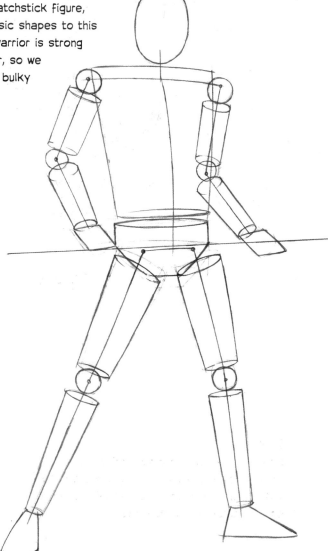

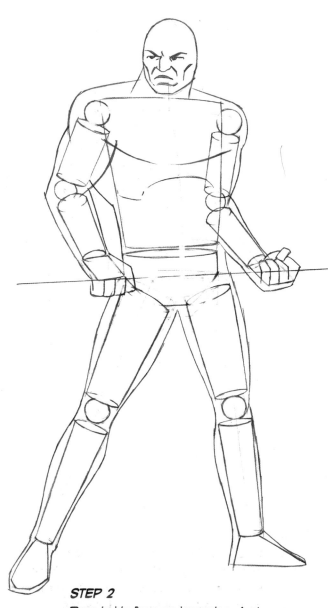

STEP 2

Draw in his face and muscles. A strong, square jawline will suit this character. Draw around the construction shapes to create the outline of your figure.

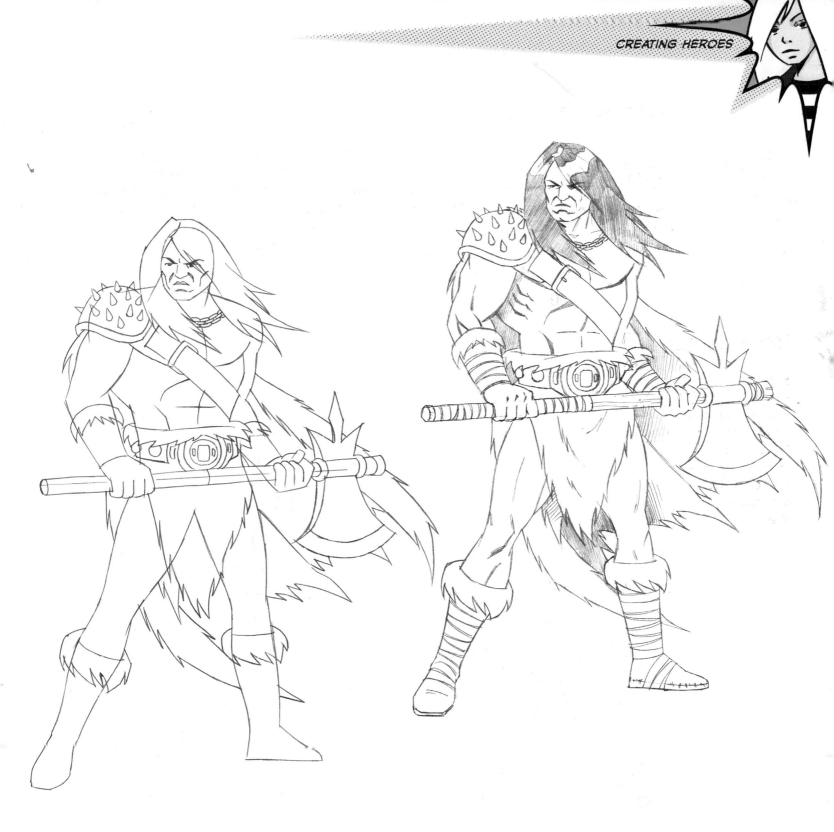

STEP 3

Remove the basic shapes so you're left with a clean outline and begin to add detail. Draw in the clothing, in this case an animal fur, leather belts and a studded shoulder plate. Draw the warrior's mighty axe.

STEP 4

Clean up the pencil drawing and add any final details. Pencil in areas of light and shade to add depth to your drawing. This will look even more effective once it's inked.

STEP 5
Carefully apply ink over
your pencil drawing.

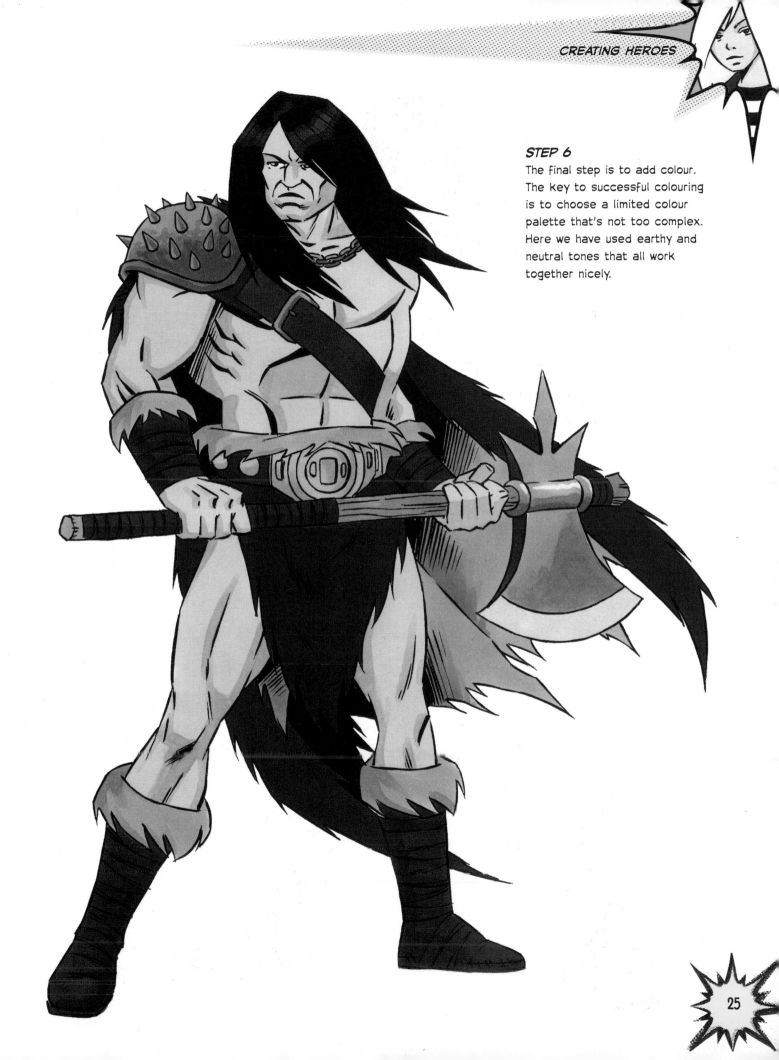

STEP 6
The final step is to add colour. The key to successful colouring is to choose a limited colour palette that's not too complex. Here we have used earthy and neutral tones that all work together nicely.

Example 2: Superheroine

STEP 1
Draw the superheroine's flying pose using the stick figure, then build on it with the basic construction shapes.

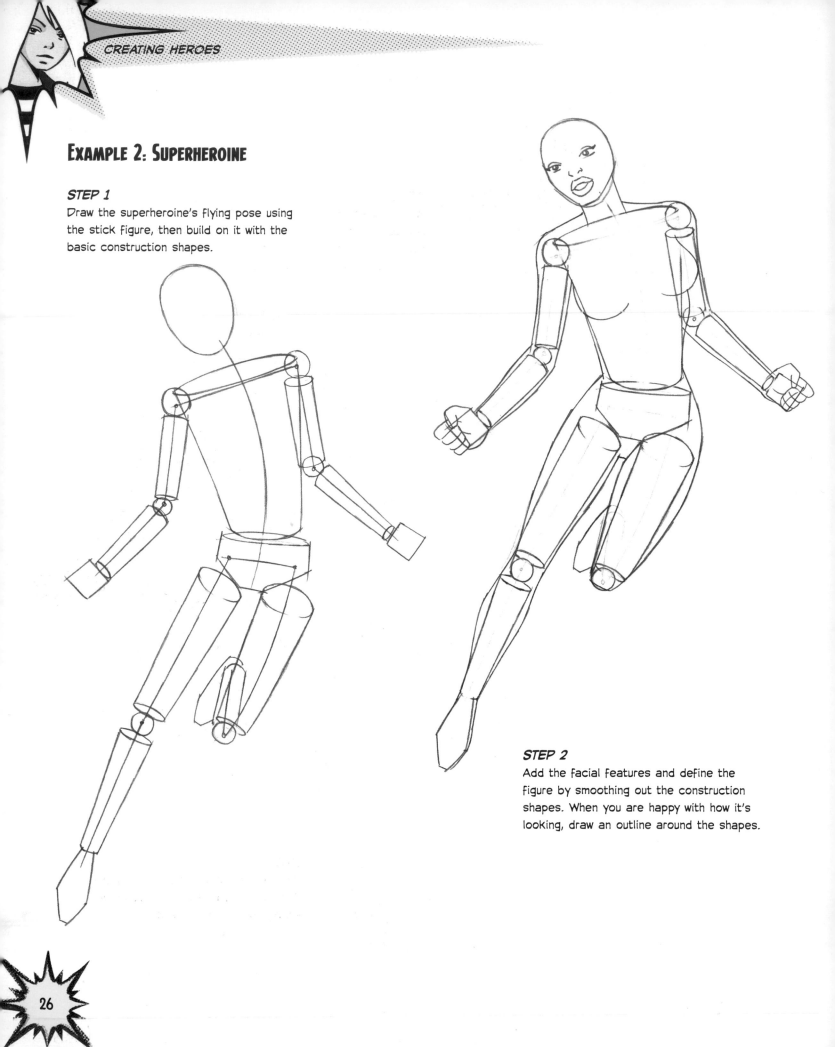

STEP 2
Add the facial features and define the figure by smoothing out the construction shapes. When you are happy with how it's looking, draw an outline around the shapes.

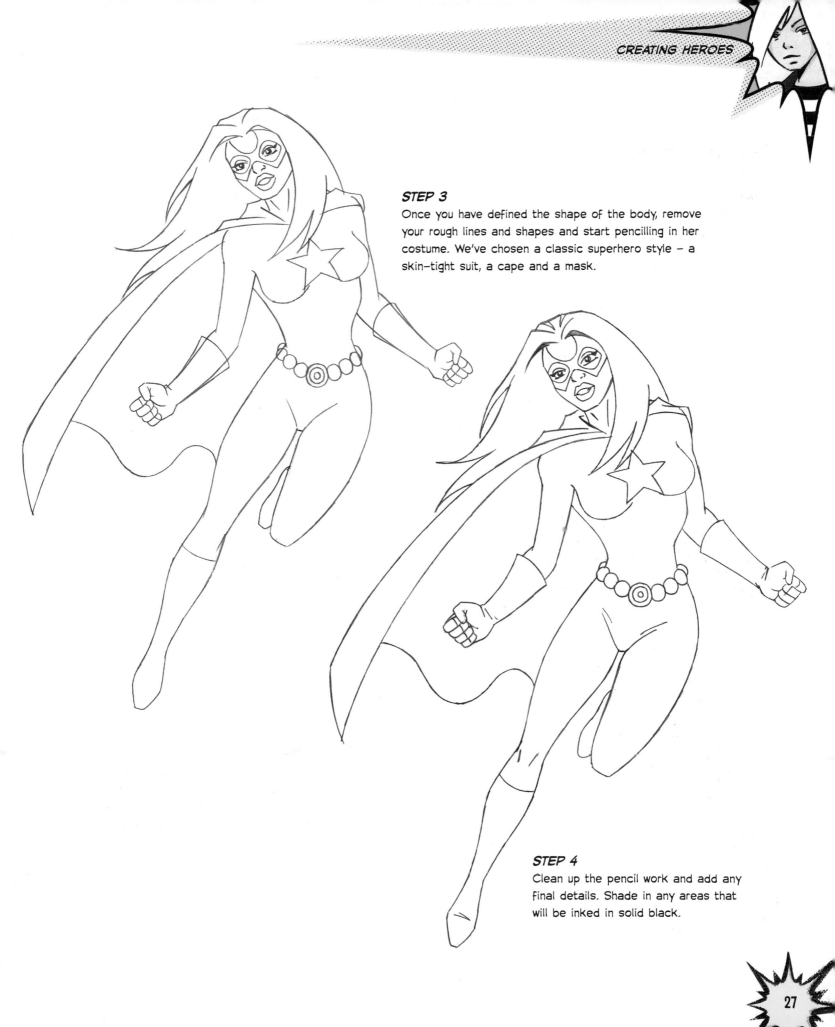

STEP 3
Once you have defined the shape of the body, remove your rough lines and shapes and start pencilling in her costume. We've chosen a classic superhero style – a skin-tight suit, a cape and a mask.

STEP 4
Clean up the pencil work and add any final details. Shade in any areas that will be inked in solid black.

STEP 5

Now carefully ink over
your pencil work to make
your drawing bolder.

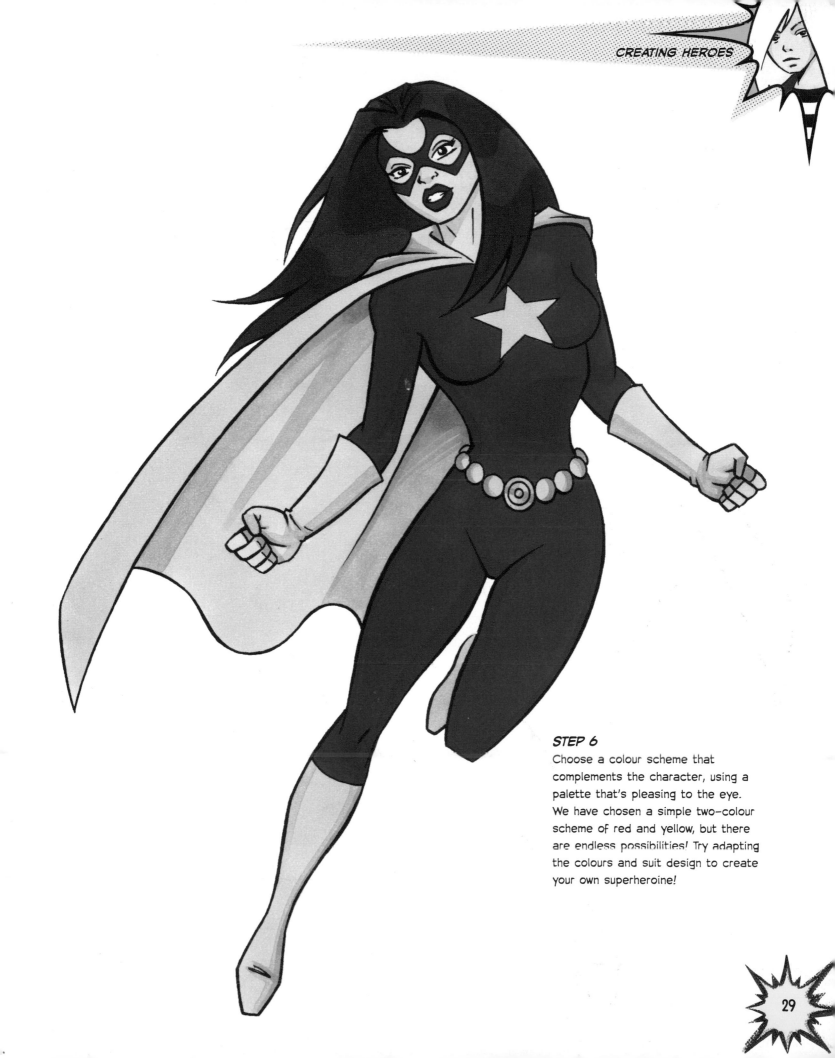

STEP 6
Choose a colour scheme that complements the character, using a palette that's pleasing to the eye. We have chosen a simple two-colour scheme of red and yellow, but there are endless possibilities! Try adapting the colours and suit design to create your own superheroine!

EXAMPLE 3: SCI-FI CYBORG

STEP 1

Construct the pose by drawing a stick figure and then add construction shapes. The cyborg has both feet firmly planted on the ground in this front-on pose.

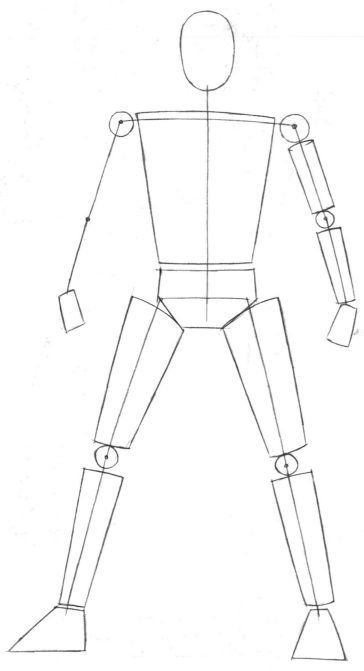

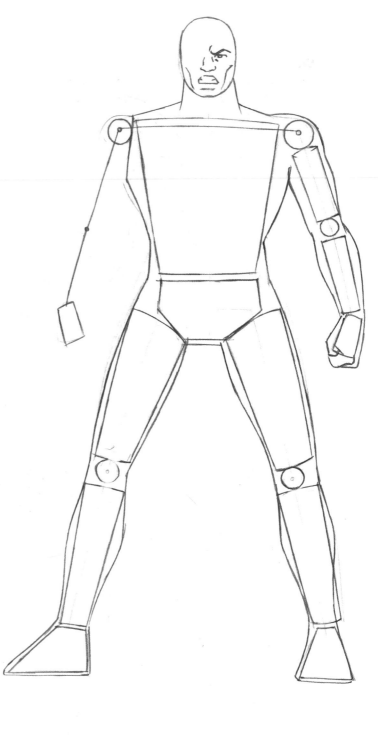

STEP 2

Using the construction shapes as a base, begin to define the muscle structure of this well-built hero. Start pencilling in the face, which is part human, part machine.

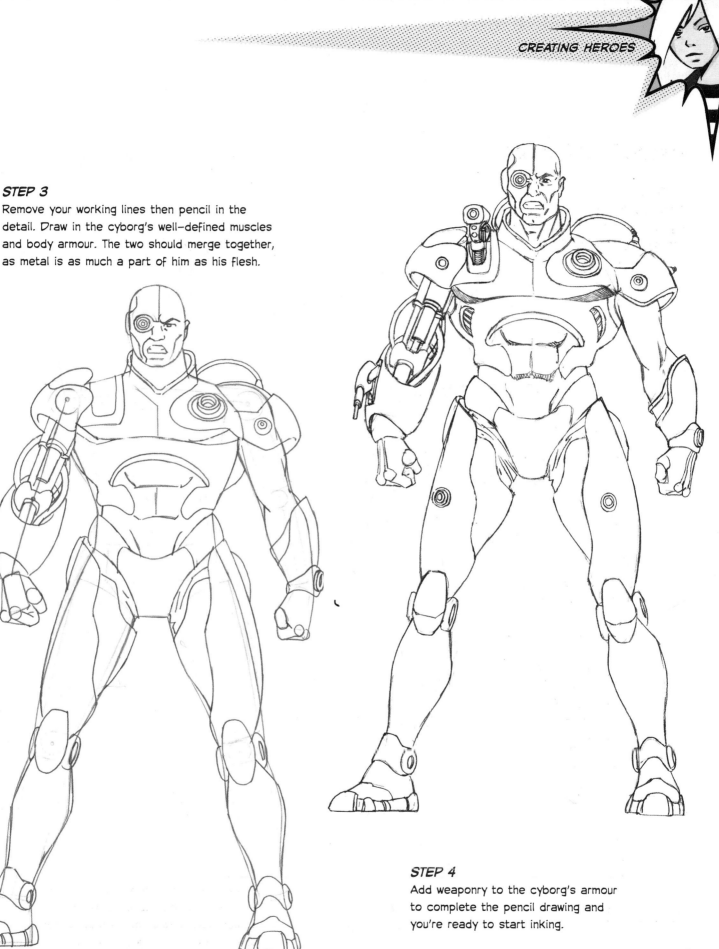

STEP 3

Remove your working lines then pencil in the detail. Draw in the cyborg's well-defined muscles and body armour. The two should merge together, as metal is as much a part of him as his flesh.

STEP 4

Add weaponry to the cyborg's armour to complete the pencil drawing and you're ready to start inking.

STEP 5
Ink over your final pencil drawing, adding solid areas of black ink to create a sense of depth, especially in and around the armour.

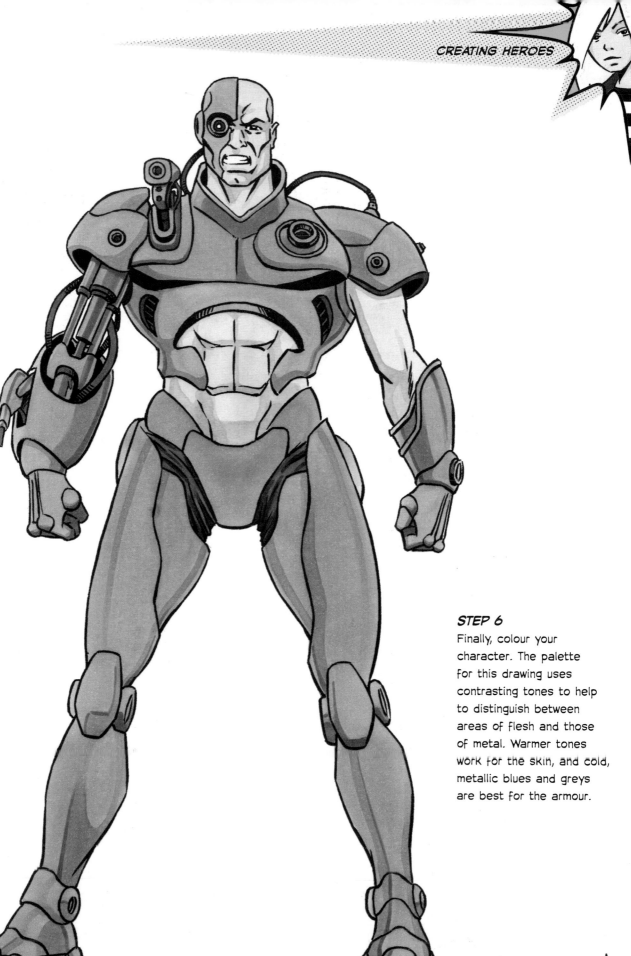

STEP 6
Finally, colour your
character. The palette
for this drawing uses
contrasting tones to help
to distinguish between
areas of flesh and those
of metal. Warmer tones
work for the skin, and cold,
metallic blues and greys
are best for the armour.

CHARACTER VARIATIONS

Here are some examples of other types of hero you could choose to create.

KUNG FU FIGHTER

Strong, dynamic poses work well for martial arts heroes.

AHOY THERE!

You could set your story on the high seas and choose a swashbuckling pirate to be your hero.

SLICK SECRET AGENT

Why not choose a strong female to be your heroine? You wouldn't want to mess with this tough, sci-fi secret agent!

THE SIDE-KICK

Will your hero have a partner? Comic book side-kicks often have different skills or knowledge from the hero and act as their support.

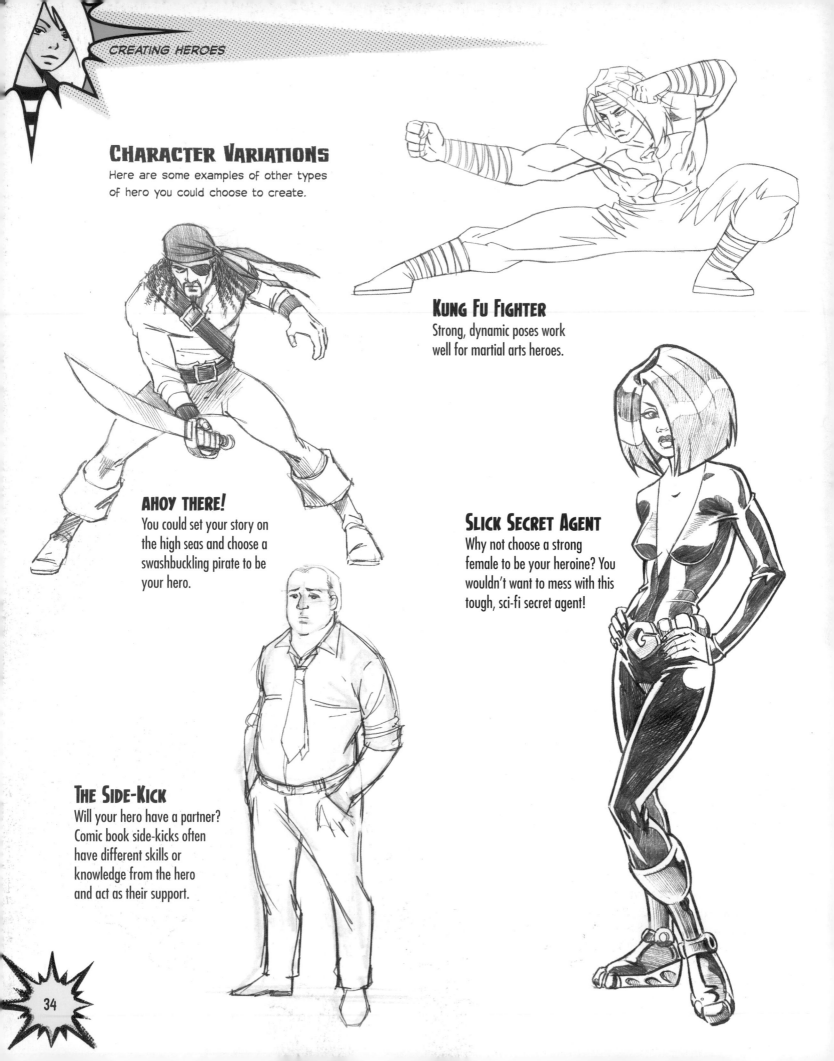

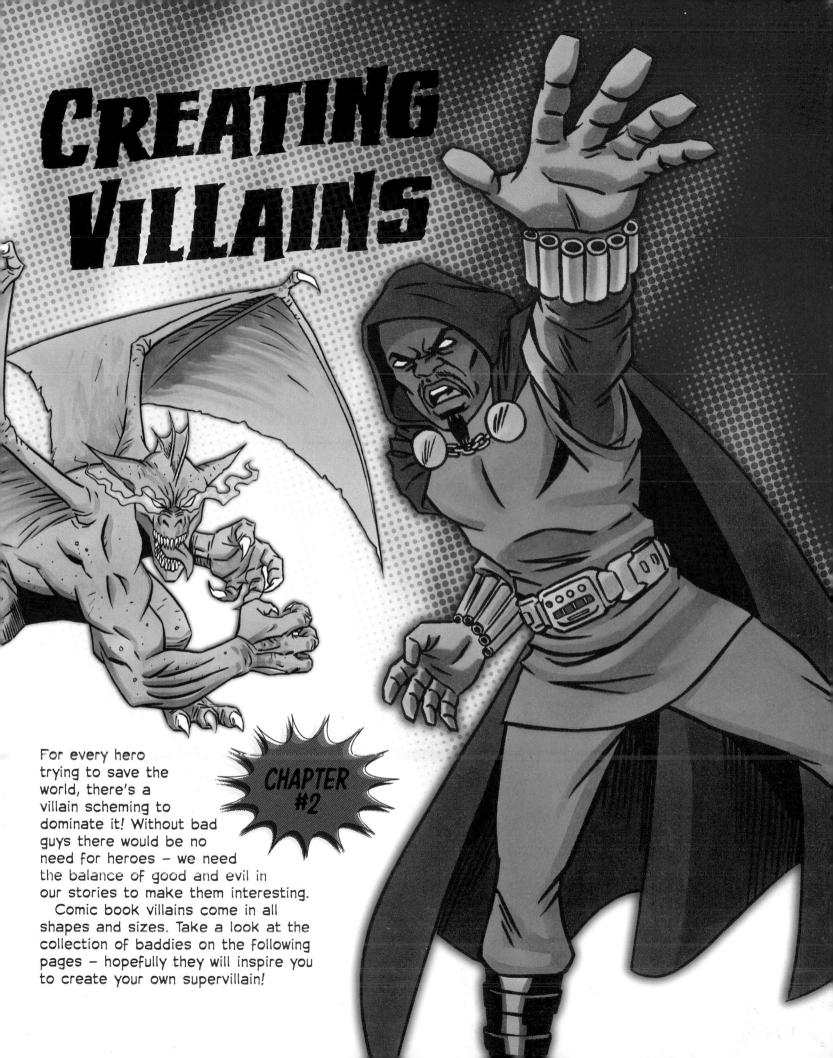

CREATING VILLAINS

CHAPTER #2

For every hero trying to save the world, there's a villain scheming to dominate it! Without bad guys there would be no need for heroes – we need the balance of good and evil in our stories to make them interesting.

Comic book villains come in all shapes and sizes. Take a look at the collection of baddies on the following pages – hopefully they will inspire you to create your own supervillain!

HOW TO MAKE A MONSTER

Everyone loves a good bad guy! You might include lots of them in your story, but for a baddy to rise up the ranks and be crowned a supervillain they must be powerful, ruthless, evil and often crazy!

Your villain's evil motives and actions are crucial to the plot of your story. What sort of bad guy will your hero be up against? Let your imagination run wild as you create your own monstrous maniac!

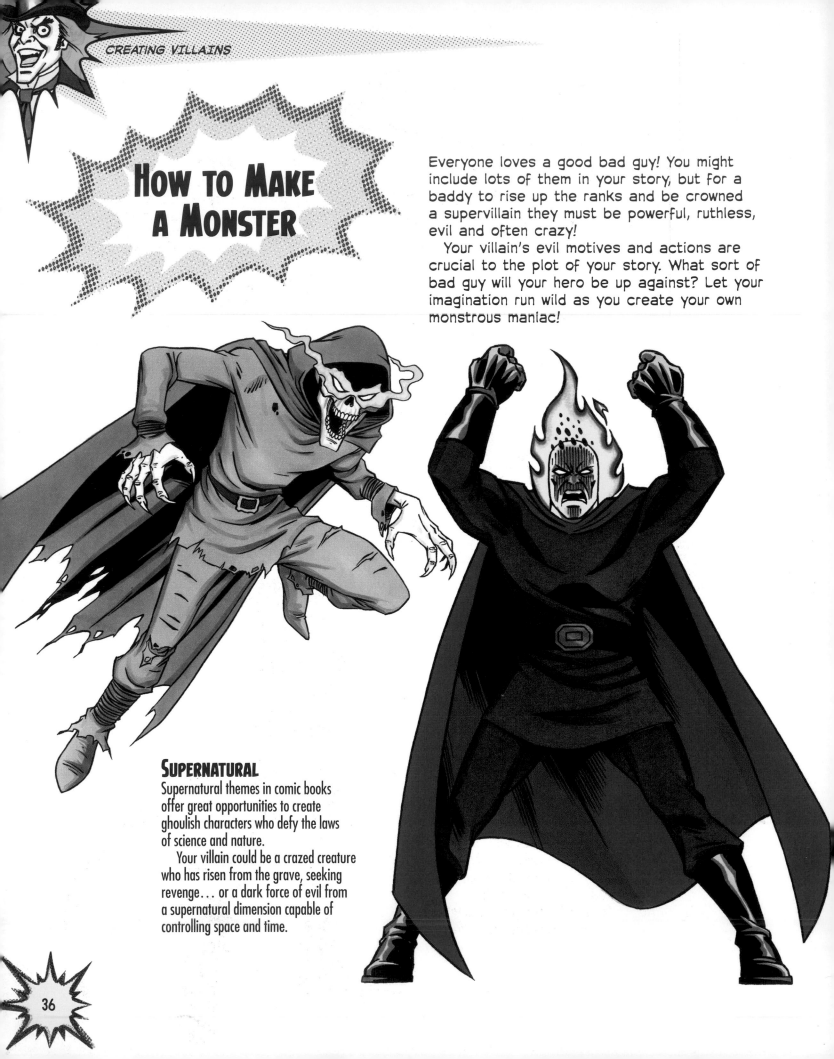

SUPERNATURAL

Supernatural themes in comic books offer great opportunities to create ghoulish characters who defy the laws of science and nature.

Your villain could be a crazed creature who has risen from the grave, seeking revenge... or a dark force of evil from a supernatural dimension capable of controlling space and time.

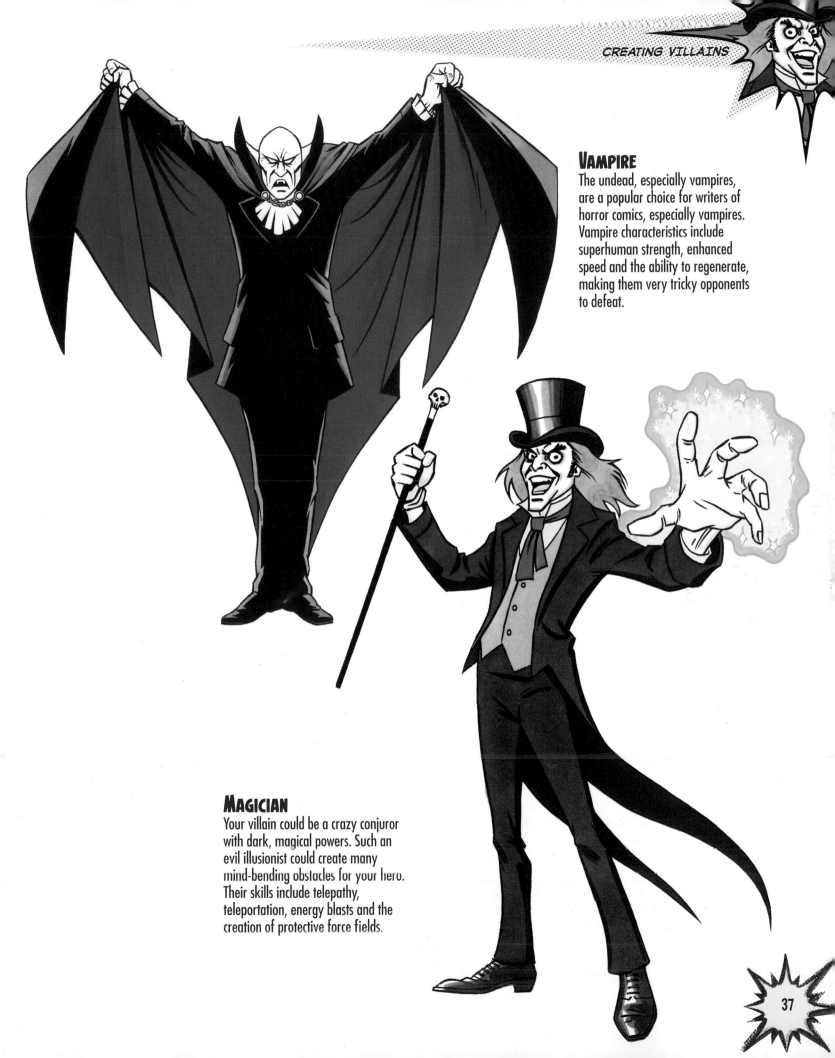

VAMPIRE

The undead, especially vampires, are a popular choice for writers of horror comics, especially vampires. Vampire characteristics include superhuman strength, enhanced speed and the ability to regenerate, making them very tricky opponents to defeat.

MAGICIAN

Your villain could be a crazy conjuror with dark, magical powers. Such an evil illusionist could create many mind-bending obstacles for your hero. Their skills include telepathy, teleportation, energy blasts and the creation of protective force fields.

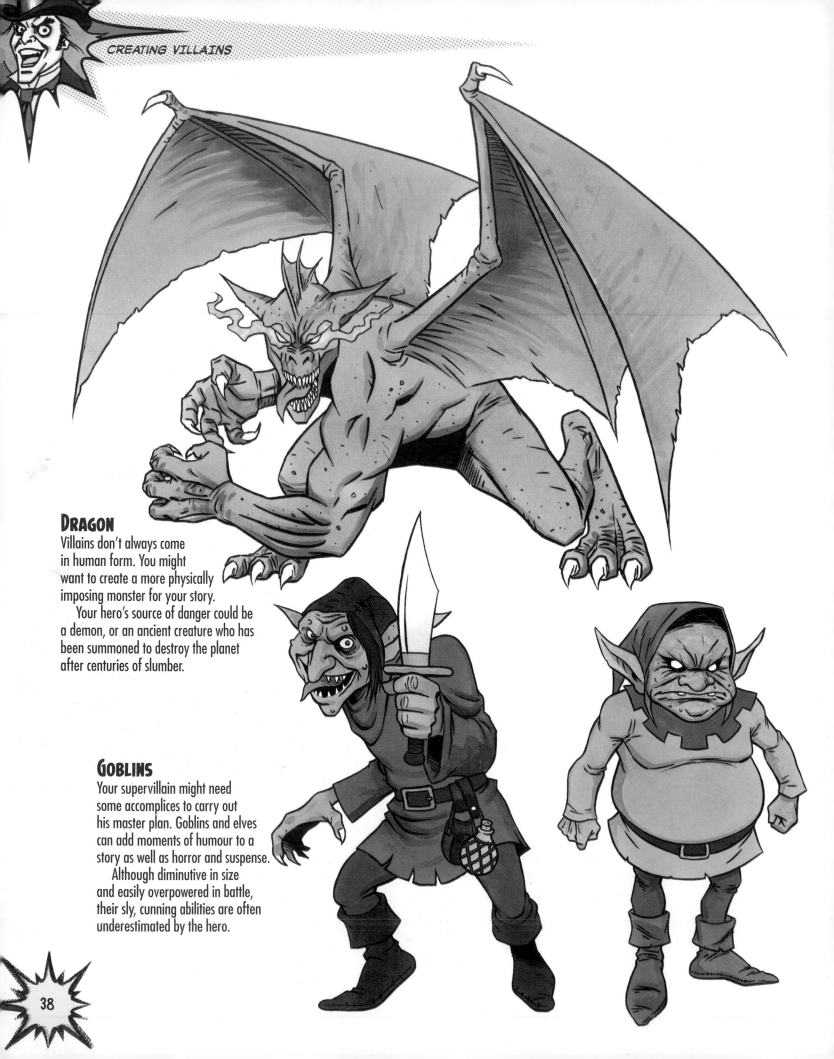

DRAGON

Villains don't always come in human form. You might want to create a more physically imposing monster for your story.

Your hero's source of danger could be a demon, or an ancient creature who has been summoned to destroy the planet after centuries of slumber.

GOBLINS

Your supervillain might need some accomplices to carry out his master plan. Goblins and elves can add moments of humour to a story as well as horror and suspense.

Although diminutive in size and easily overpowered in battle, their sly, cunning abilities are often underestimated by the hero.

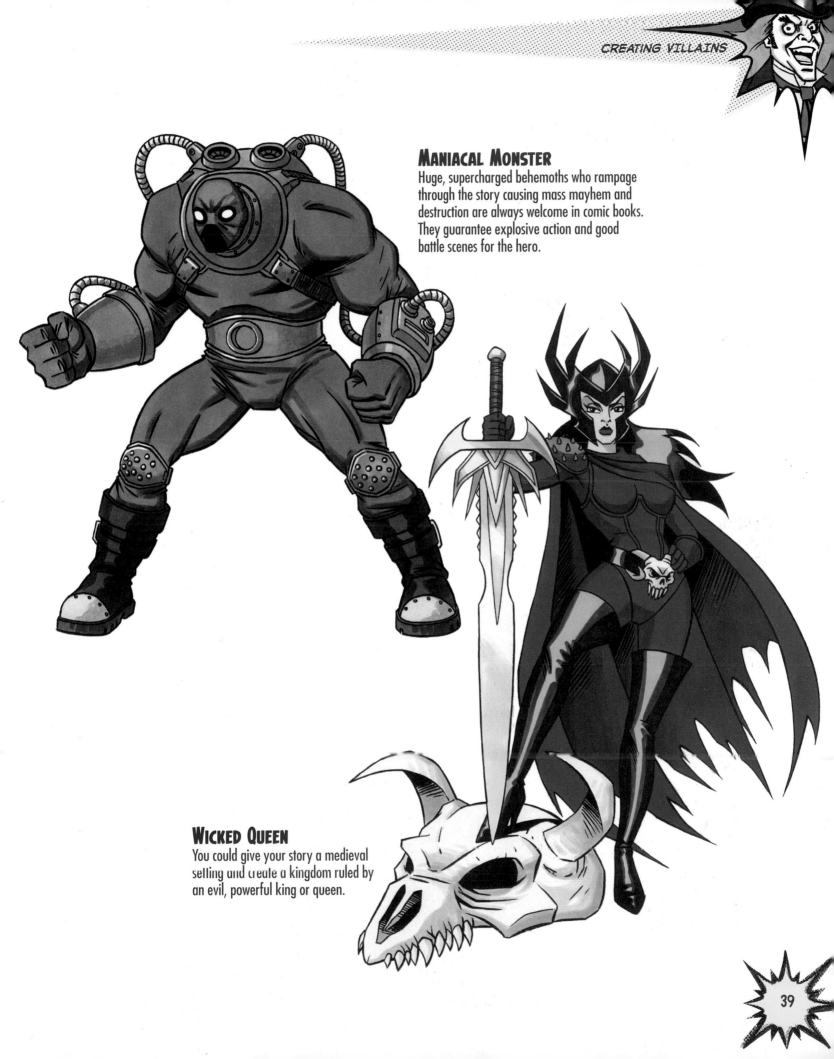

MANIACAL MONSTER

Huge, supercharged behemoths who rampage through the story causing mass mayhem and destruction are always welcome in comic books. They guarantee explosive action and good battle scenes for the hero.

WICKED QUEEN

You could give your story a medieval setting and create a kingdom ruled by an evil, powerful king or queen.

39

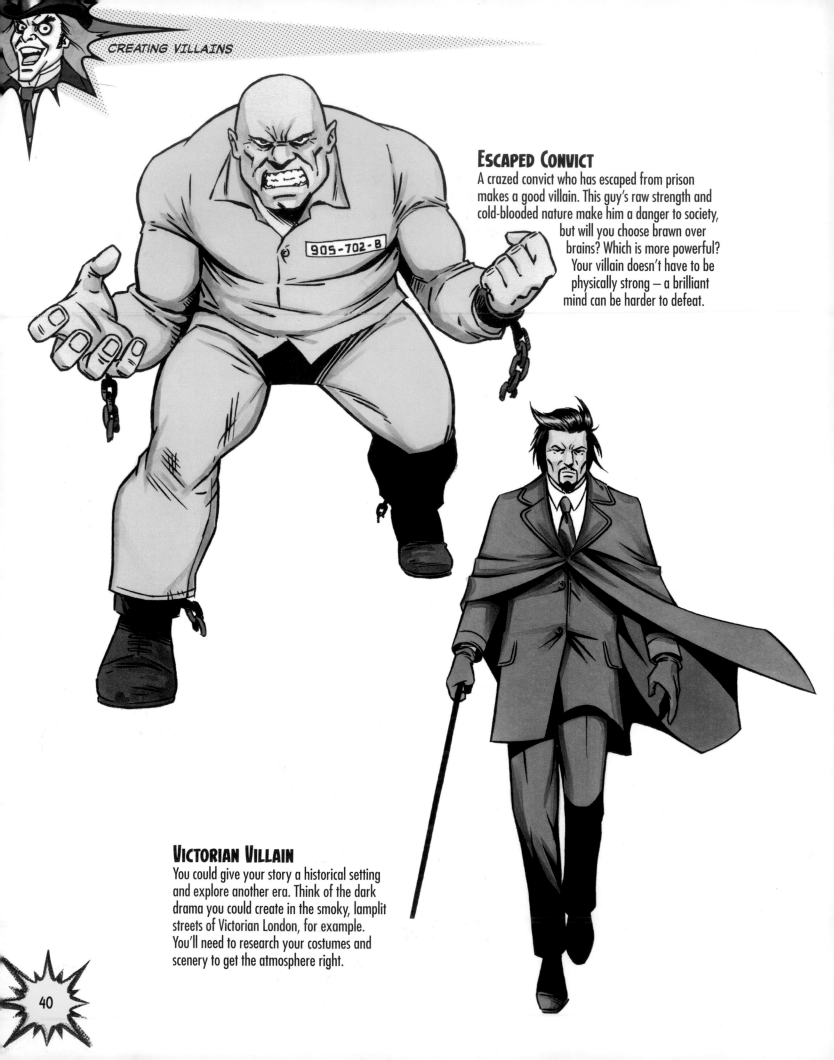

ESCAPED CONVICT

A crazed convict who has escaped from prison makes a good villain. This guy's raw strength and cold-blooded nature make him a danger to society, but will you choose brawn over brains? Which is more powerful? Your villain doesn't have to be physically strong — a brilliant mind can be harder to defeat.

VICTORIAN VILLAIN

You could give your story a historical setting and explore another era. Think of the dark drama you could create in the smoky, lamplit streets of Victorian London, for example. You'll need to research your costumes and scenery to get the atmosphere right.

905-702-B

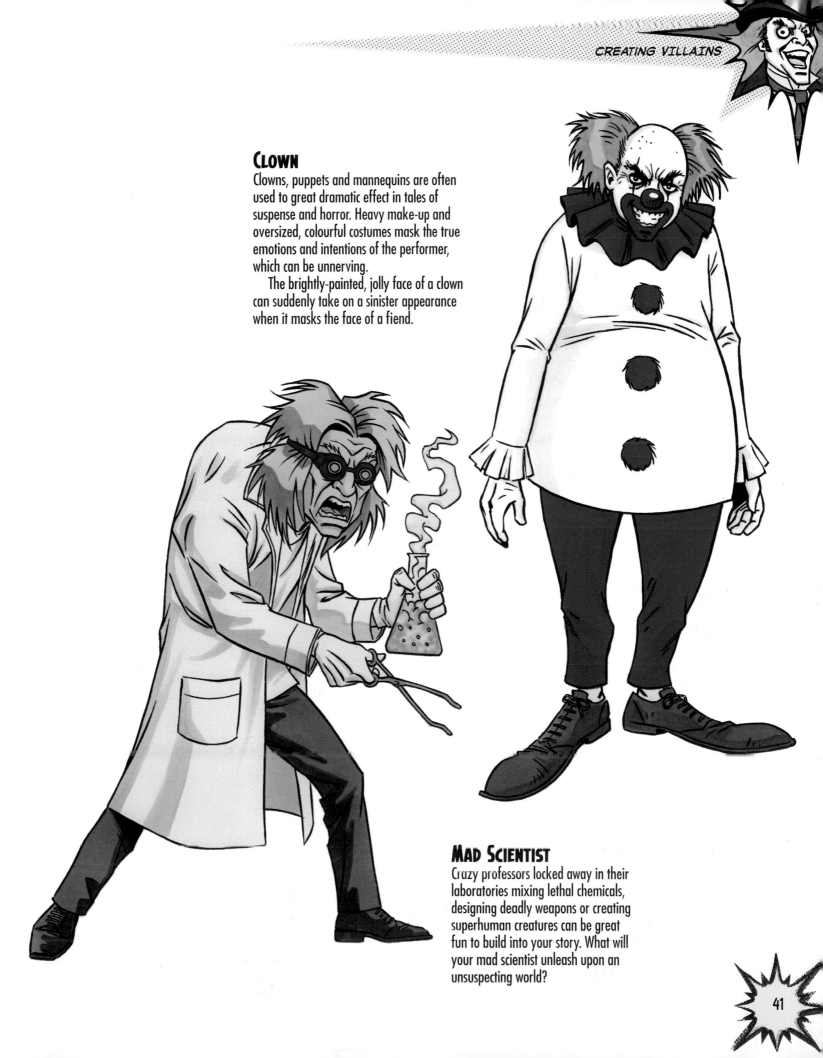

CLOWN

Clowns, puppets and mannequins are often used to great dramatic effect in tales of suspense and horror. Heavy make-up and oversized, colourful costumes mask the true emotions and intentions of the performer, which can be unnerving.

The brightly-painted, jolly face of a clown can suddenly take on a sinister appearance when it masks the face of a fiend.

MAD SCIENTIST

Crazy professors locked away in their laboratories mixing lethal chemicals, designing deadly weapons or creating superhuman creatures can be great fun to build into your story. What will your mad scientist unleash upon an unsuspecting world?

CONSTRUCTING YOUR VILLAIN

In this section you'll learn how to draw three different villains. Whatever form your villain takes, the technique of building up a figure using basic shapes can be adapted and applied when creating your own character.

EXAMPLE 1: ESCAPED CONVICT

STEP 1
Start by drawing the stick figure, then add construction shapes to flesh him out.

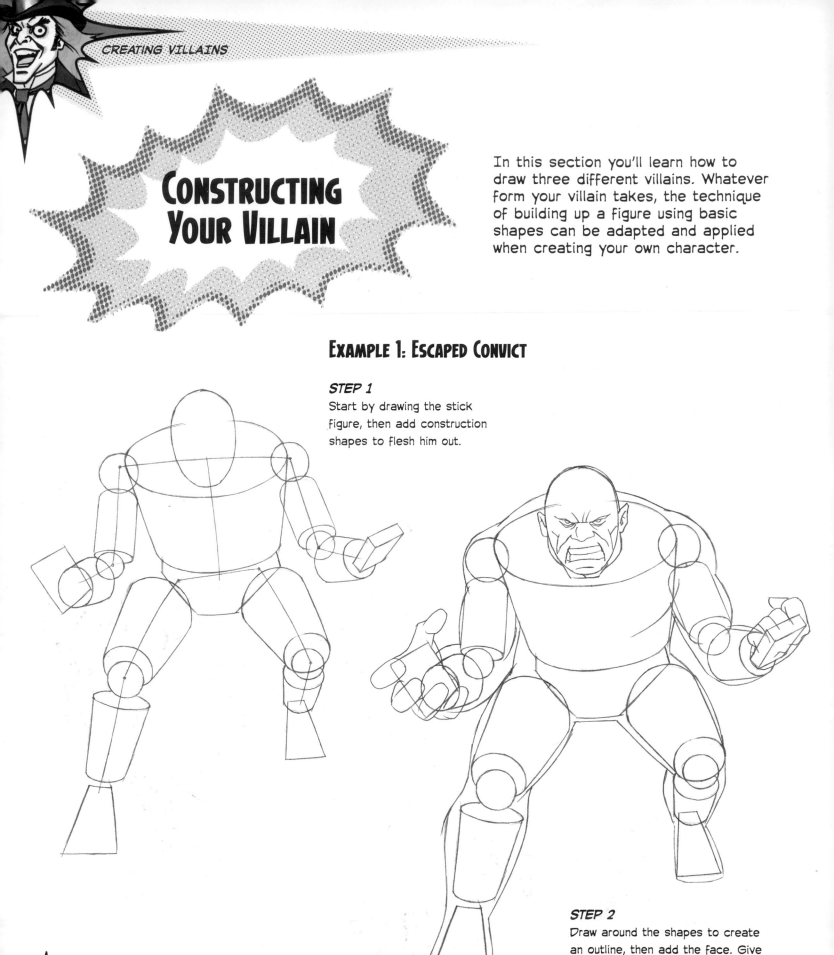

STEP 2
Draw around the shapes to create an outline, then add the face. Give him a mean expression and gritted teeth, as if he's snarling.

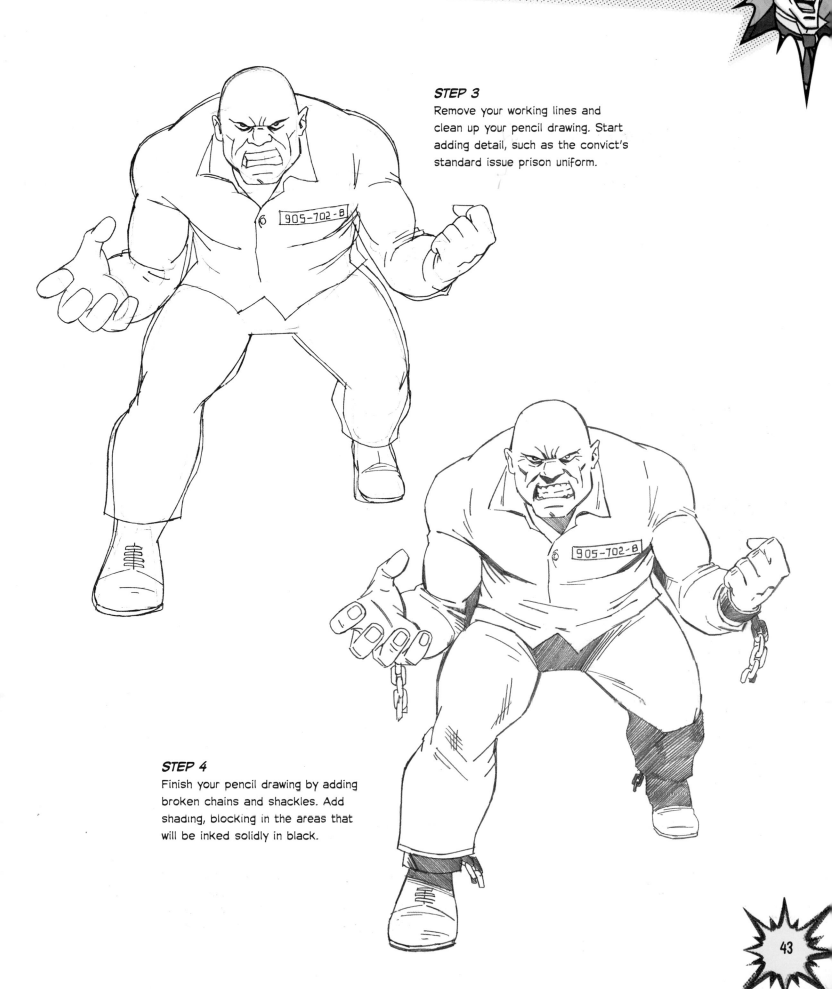

STEP 3
Remove your working lines and clean up your pencil drawing. Start adding detail, such as the convict's standard issue prison uniform.

905-702-8

STEP 4
Finish your pencil drawing by adding broken chains and shackles. Add shading, blocking in the areas that will be inked solidly in black.

905-702-8

905-702-B

STEP 5
Carefully following your
pencil lines, ink your
drawing to give it more
strength and power.

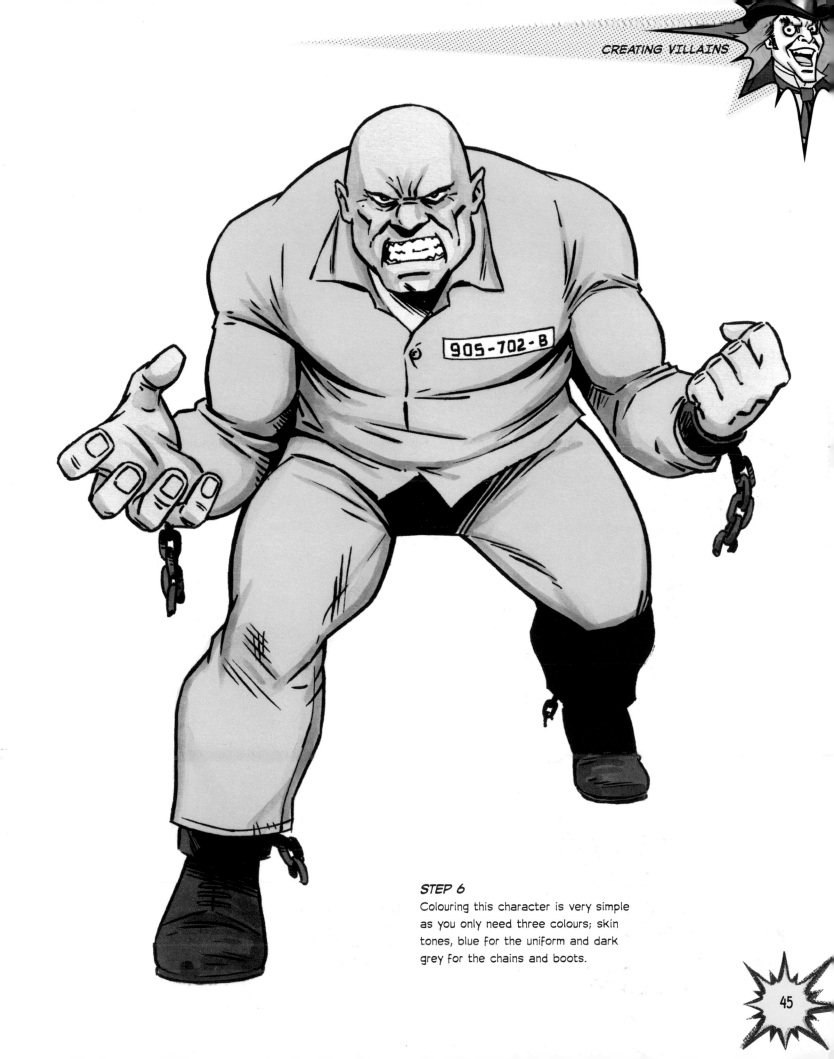

STEP 6
Colouring this character is very simple as you only need three colours; skin tones, blue for the uniform and dark grey for the chains and boots.

EXAMPLE 2: WICKED QUEEN

STEP 1
Build the figure using the stick frame and construction shapes. This warrior queen has a powerful pose.

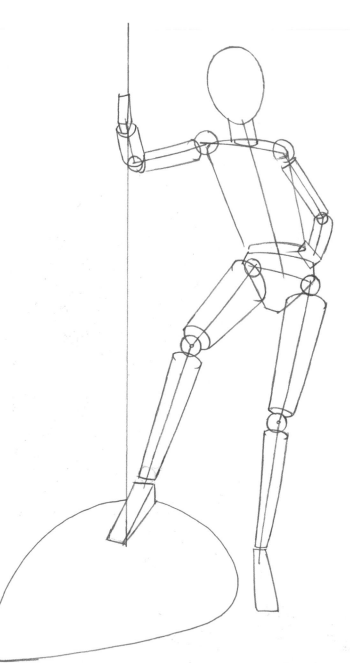

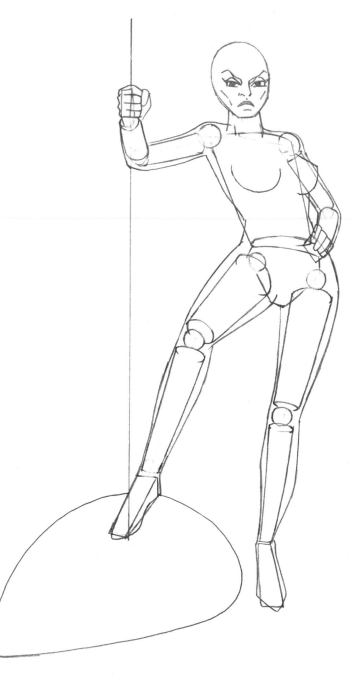

STEP 2
Refine the body shape by outlining around the construction shapes. Draw in the face, giving the queen a tough, scornful expression.

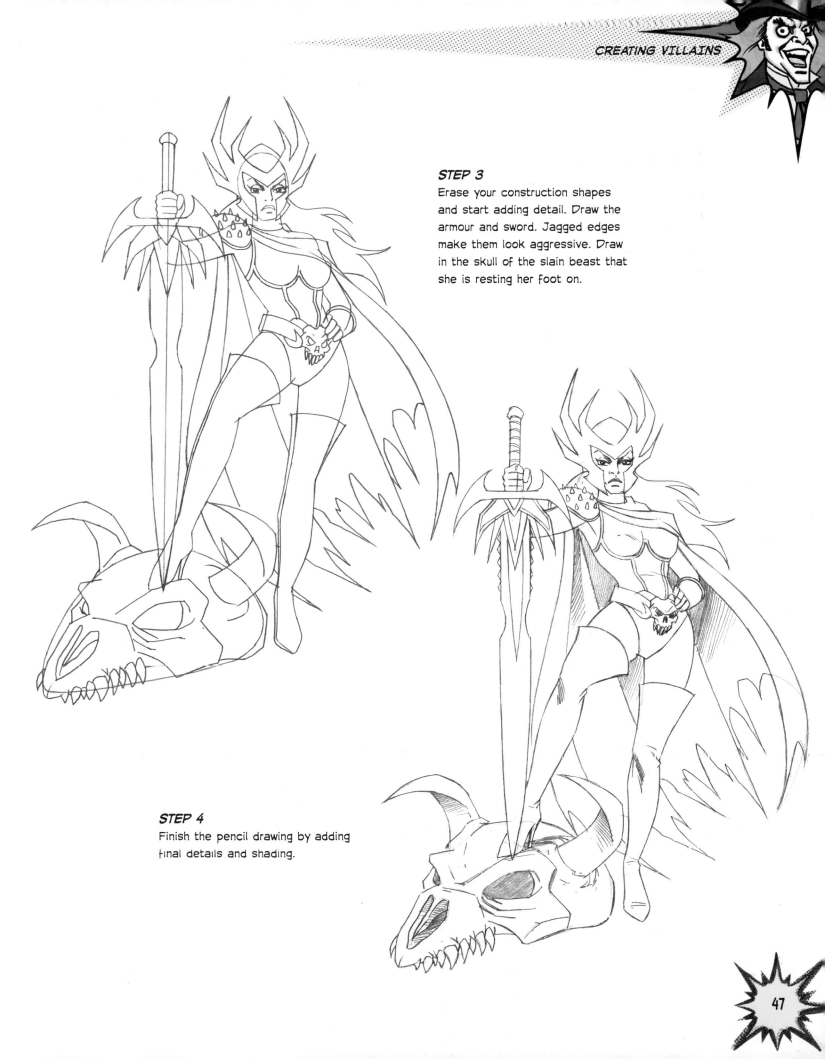

STEP 3

Erase your construction shapes and start adding detail. Draw the armour and sword. Jagged edges make them look aggressive. Draw in the skull of the slain beast that she is resting her foot on.

STEP 4

Finish the pencil drawing by adding final details and shading.

STEP 5
Carefully ink over your
pencil drawing.

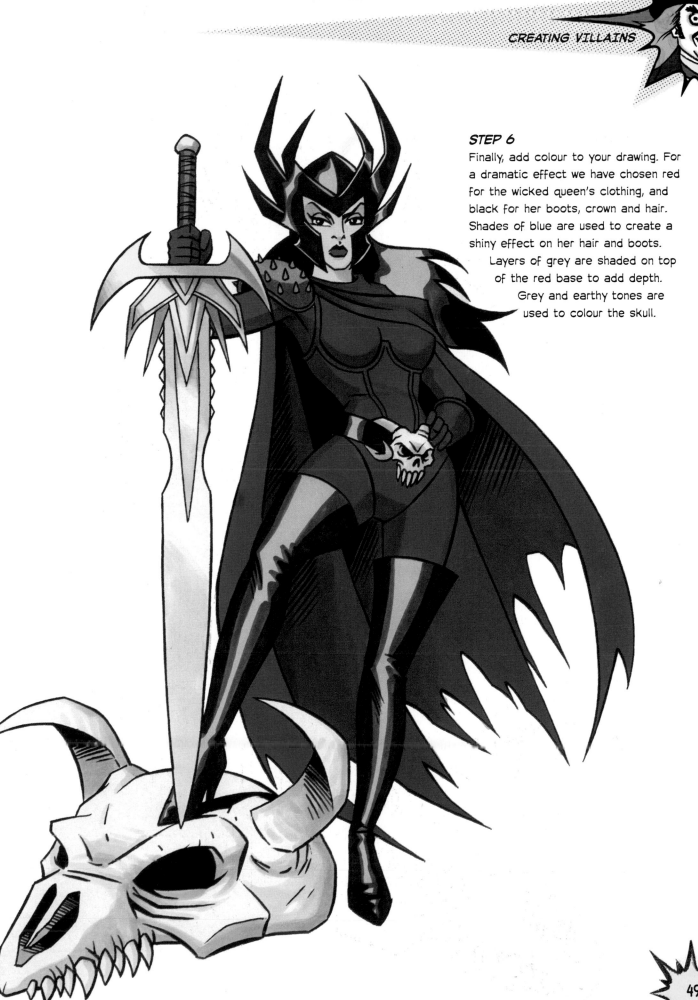

STEP 6

Finally, add colour to your drawing. For a dramatic effect we have chosen red for the wicked queen's clothing, and black for her boots, crown and hair. Shades of blue are used to create a shiny effect on her hair and boots. Layers of grey are shaded on top of the red base to add depth. Grey and earthy tones are used to colour the skull.

Example 3: Mad Scientist

STEP 1
Start to draw the figure using the stick frame and construction shapes.

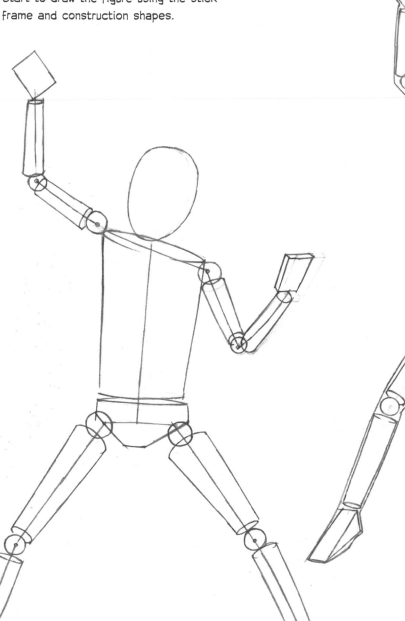

STEP 2
Draw the face and hair. Give this character an exaggerated, crazed expression that leaves the reader in no doubt that this person is MAD!

STEP 3

Clean up your pencil work and draw the clothing. We've chosen a classic lab coat for this nutty professor. Draw the bubbling potion he is holding.

STEP 4

Finalize your pencil drawing by adding shading, to prepare it for inking.

STEP 5
Ink your pencil drawing by faithfully going over your pencil work.

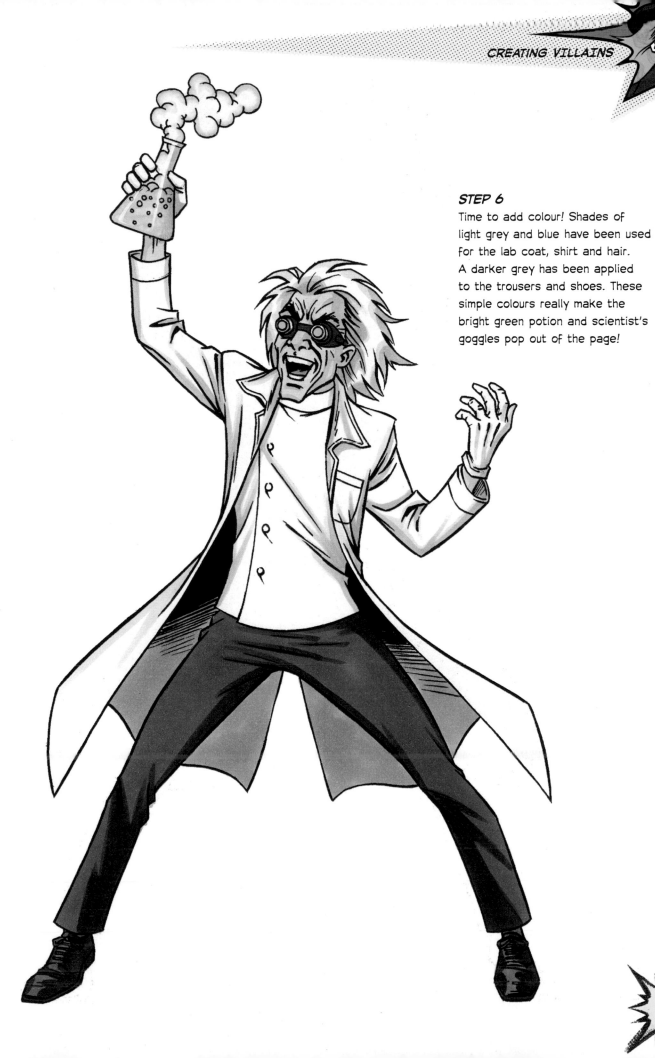

STEP 6

Time to add colour! Shades of light grey and blue have been used for the lab coat, shirt and hair. A darker grey has been applied to the trousers and shoes. These simple colours really make the bright green potion and scientist's goggles pop out of the page!

CHARACTER VARIATIONS

Here are some examples of other types of villain you could choose to create.

DEADLY DEMON

Your villain could be a demon – the very embodiment of evil.

WICKED WARLORD

A crazy military mastermind with evil ambitions could rise to power in your story.

MAFIA BOSS

Mafia bosses are ruthless, powerful characters. Gangsters make great villains and are characters we love to hate.

KUNG FU WARRIOR

A super-powered martial artist is a formidable opponent for any hero.

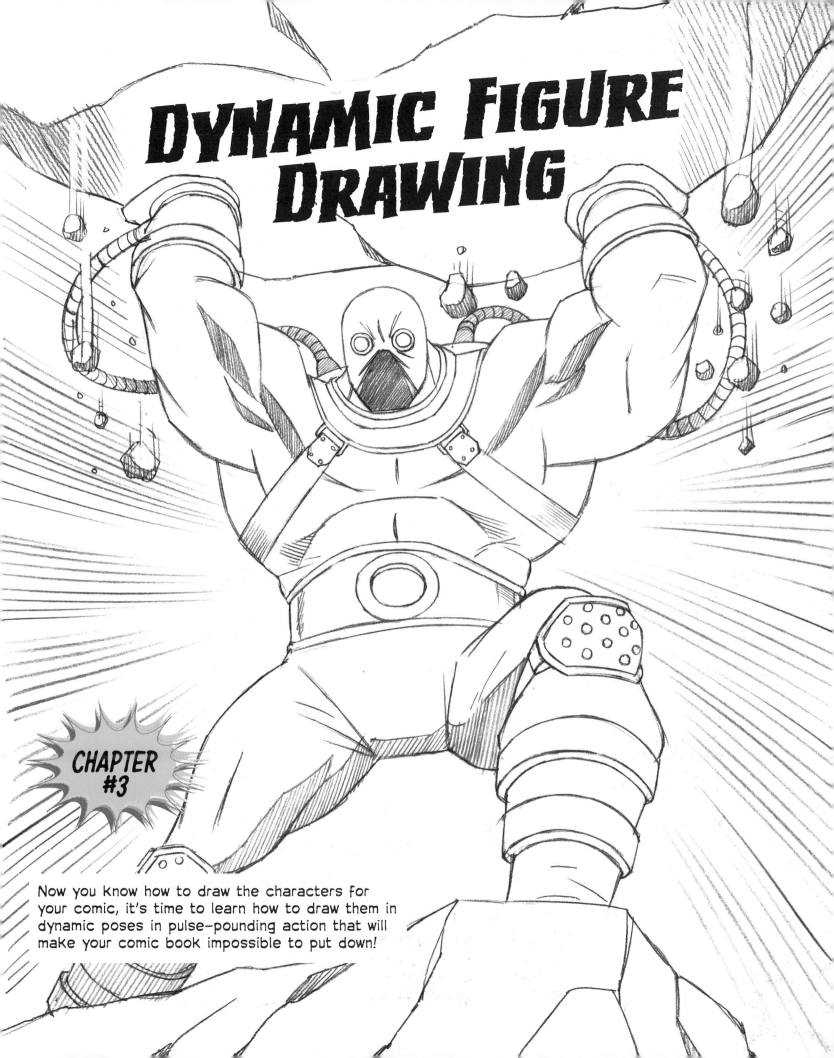

Dynamic Figure Drawing

CHAPTER #3

Now you know how to draw the characters for your comic, it's time to learn how to draw them in dynamic poses in pulse-pounding action that will make your comic book impossible to put down!

ACTION!

This chapter is all about action and learning how to make your comic book panels more interesting by animating your characters.

Once you've become familiar with the process of how to construct the human figure, it's time to develop those skills so you can transform simple stances into explosive action poses!

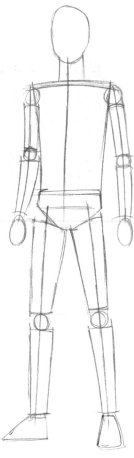
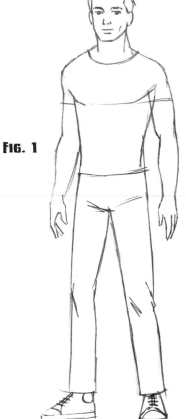

FIG. 1

STANDING

Study the figures on this page. The first character (Fig. 1) is standing in a lifeless, uninteresting pose, but the second (Fig. 2) is shown in a ready-for-action pose!

Look at the construction diagrams that show how the two figures were composed and examine the differences. Even if your character is just standing still, the use of dynamic figure poses brings him to life, making your comic book pages look much more exciting.

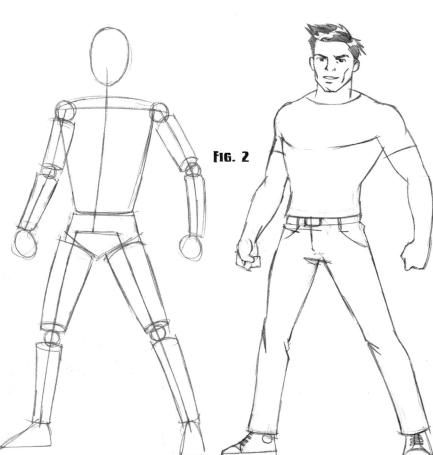

FIG. 2

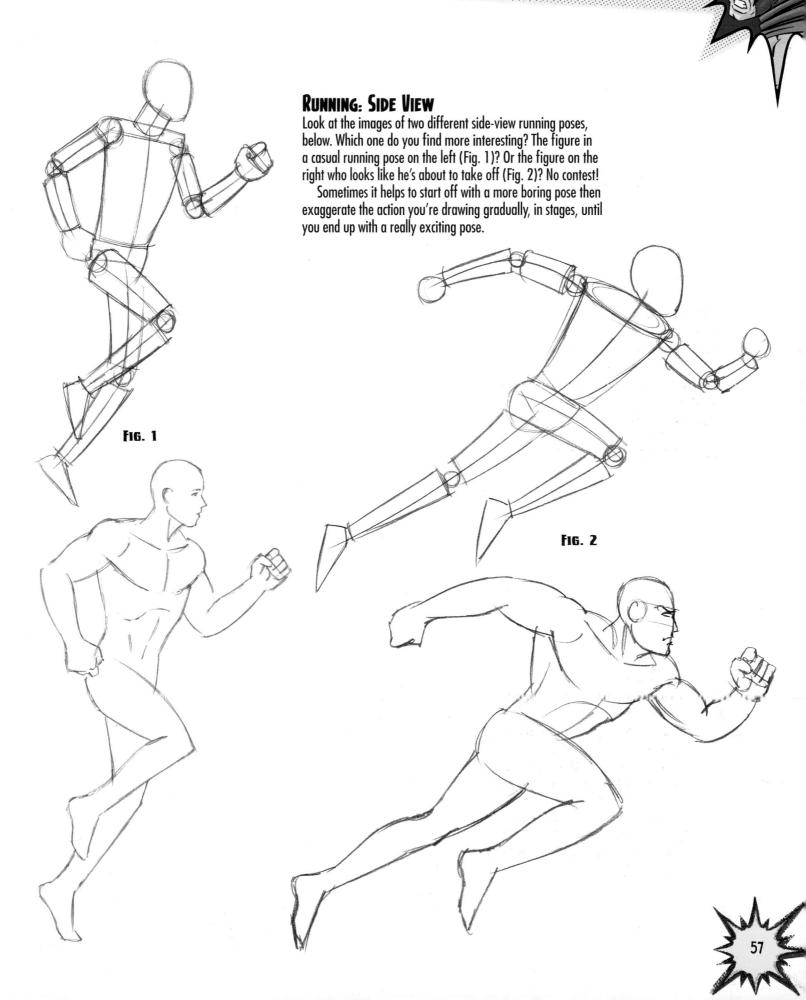

RUNNING: SIDE VIEW

Look at the images of two different side-view running poses, below. Which one do you find more interesting? The figure in a casual running pose on the left (Fig. 1)? Or the figure on the right who looks like he's about to take off (Fig. 2)? No contest!

Sometimes it helps to start off with a more boring pose then exaggerate the action you're drawing gradually, in stages, until you end up with a really exciting pose.

FIG. 1

FIG. 2

RUNNING: FRONT VIEW

Here's another running pose, this time viewed from the front. Notice how in the dynamic version (Fig. 2) you can really feel the action — it looks like the figure could leap off the page towards you!

The images that you find exciting are, in turn, the ones the reader of your comic book will find exciting.

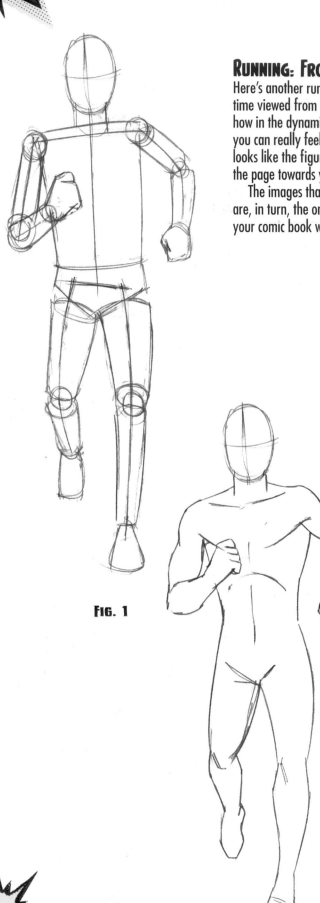

FIG. 1

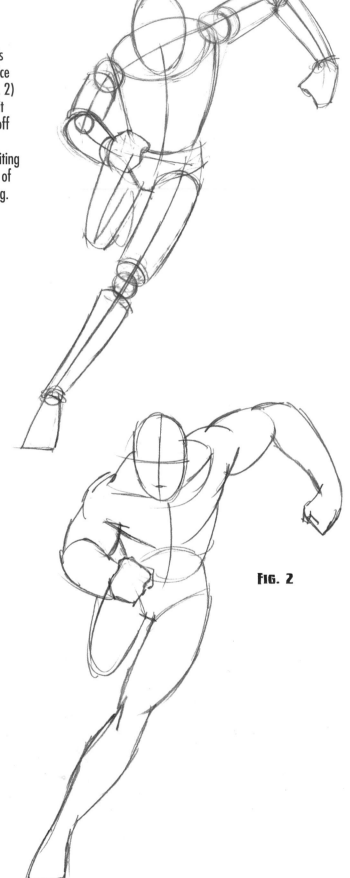

FIG. 2

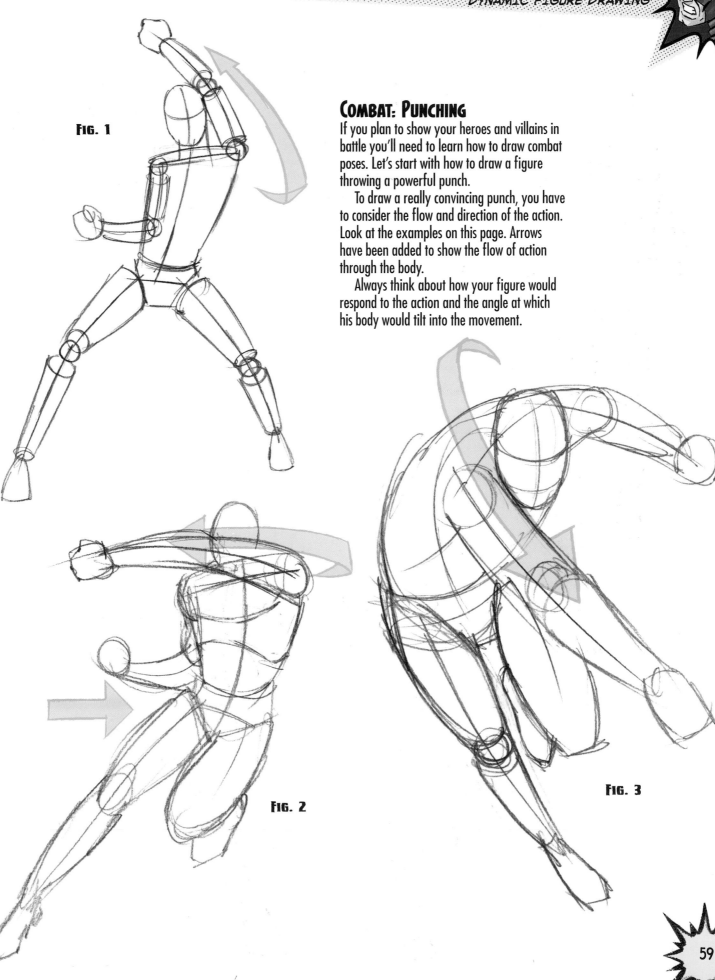

FIG. 1

COMBAT: PUNCHING

If you plan to show your heroes and villains in battle you'll need to learn how to draw combat poses. Let's start with how to draw a figure throwing a powerful punch.

To draw a really convincing punch, you have to consider the flow and direction of the action. Look at the examples on this page. Arrows have been added to show the flow of action through the body.

Always think about how your figure would respond to the action and the angle at which his body would tilt into the movement.

FIG. 2

FIG. 3

FIG. 1

COMBAT: KICKING

Here we have some different types of dynamic kicking actions. Martial arts masters are often seen in kicking poses as they show off their skills in the art of combat.

Look at the three figures. Fig. 1 is throwing a side kick, Fig. 2 is in a flying kick pose and Fig. 3 could be delivering a kick high up on his opponent's body.

FIG. 2

FIG. 3

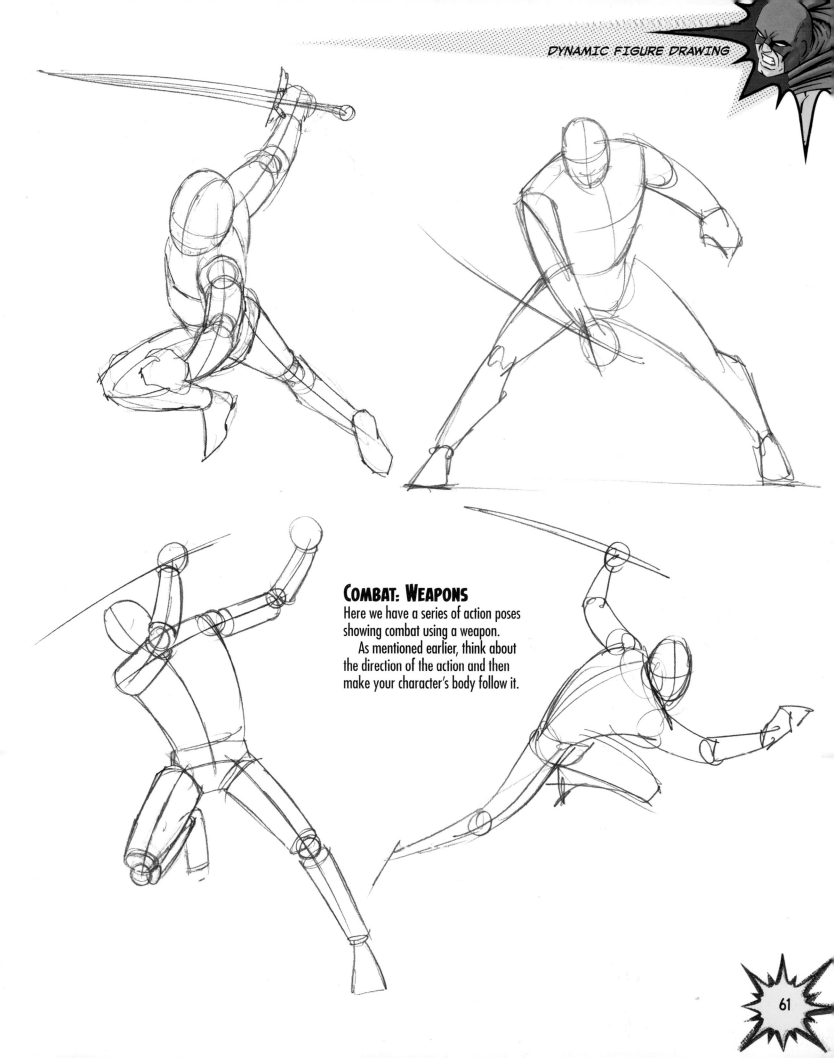

COMBAT: WEAPONS

Here we have a series of action poses showing combat using a weapon.

As mentioned earlier, think about the direction of the action and then make your character's body follow it.

JUMPING AND LEAPING

Whether it's to show your superhero leaping into action to save someone in danger, or your bad guy pouncing in attack, you need to know how to draw all sorts of different jumping poses!

Look at the examples on the following pages. All of the action poses are exciting and dynamic. It might take several attempts to get the right pose, but it's worth the effort.

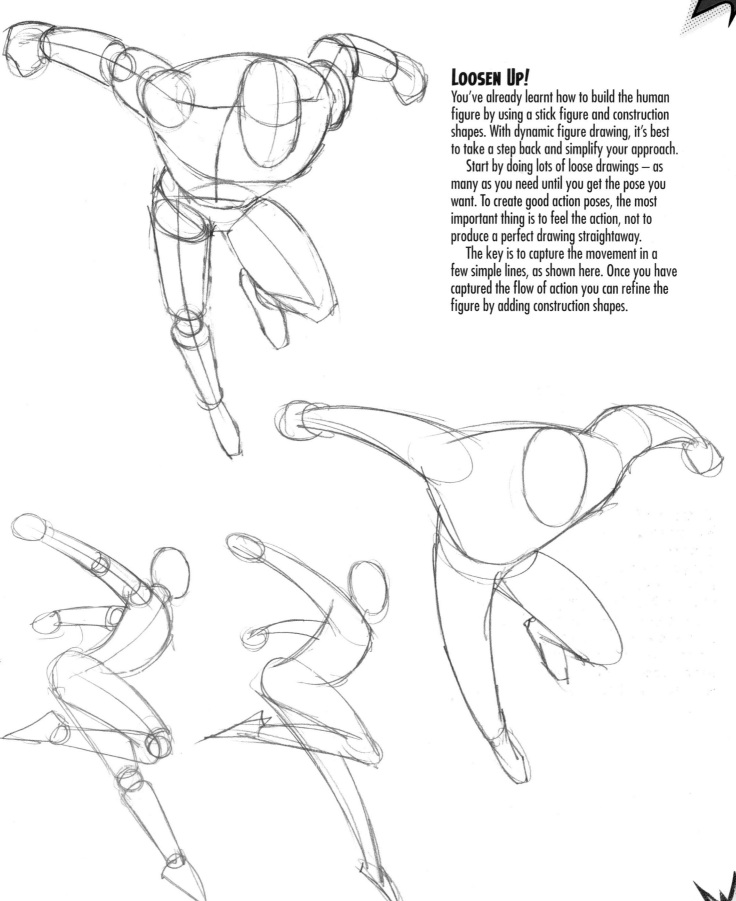

LOOSEN UP!

You've already learnt how to build the human figure by using a stick figure and construction shapes. With dynamic figure drawing, it's best to take a step back and simplify your approach.

Start by doing lots of loose drawings — as many as you need until you get the pose you want. To create good action poses, the most important thing is to feel the action, not to produce a perfect drawing straightaway.

The key is to capture the movement in a few simple lines, as shown here. Once you have captured the flow of action you can refine the figure by adding construction shapes.

Easy Steps to Action Poses

The following pages show two examples of dynamic poses broken down into five easy-to-follow stages.

Example 1: Superhero

Here's how to draw our superhero leaping into action! Note - you can see this character in colour on page 17.

STEP 1
Start by creating the loose, skeletal matchstick figure.

STEP 2
Start to flesh out the figure using the construction shapes.

STEP 3
Now begin to develop the outer form of the figure, adding basic muscle detail. At this stage you should keep your pencil sketch loose and light.

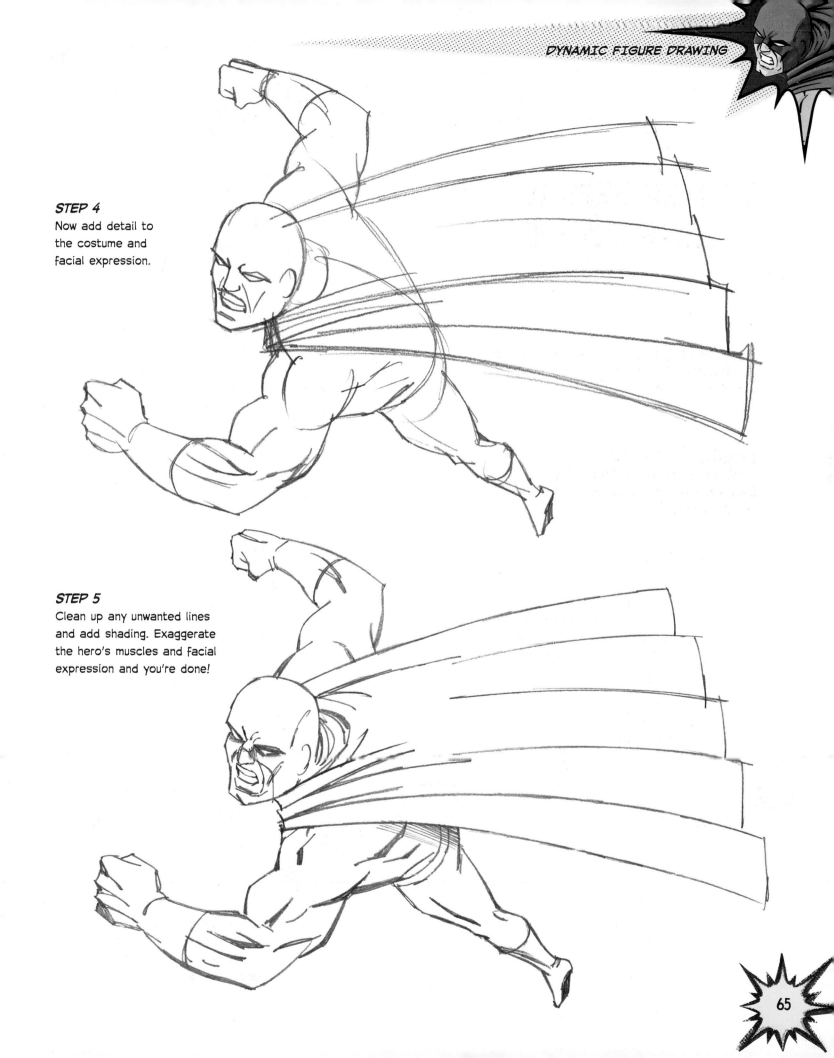

STEP 4
Now add detail to
the costume and
facial expression.

STEP 5
Clean up any unwanted lines
and add shading. Exaggerate
the hero's muscles and facial
expression and you're done!

EXAMPLE 2: BLUE LIGHTNING

Here we have a superheroine using her superhuman powers to command energy. Note — you can see this character in colour on page 18.

STEP 1

Start by drawing the basic stick figure.

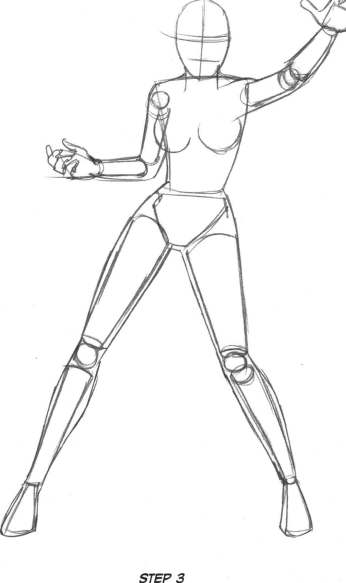

STEP 2

Build up your figure by adding basic shapes.

STEP 3

Draw an outline around the shapes to flesh out your figure. Draw in the hands and map out the proportions of the face.

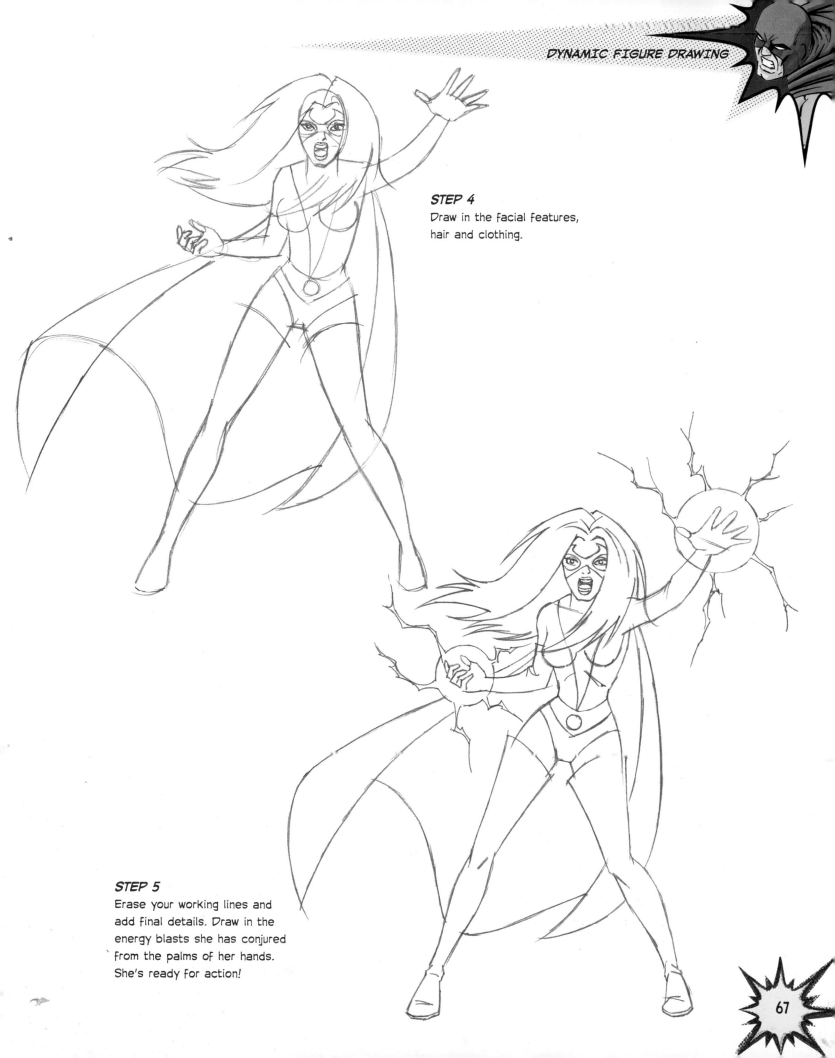

STEP 4
Draw in the facial features, hair and clothing.

STEP 5
Erase your working lines and add final details. Draw in the energy blasts she has conjured from the palms of her hands. She's ready for action!

67

ACTION GALLERY

Here are some more examples of exciting action poses for you to practise. Try following them through to a final stage drawing.

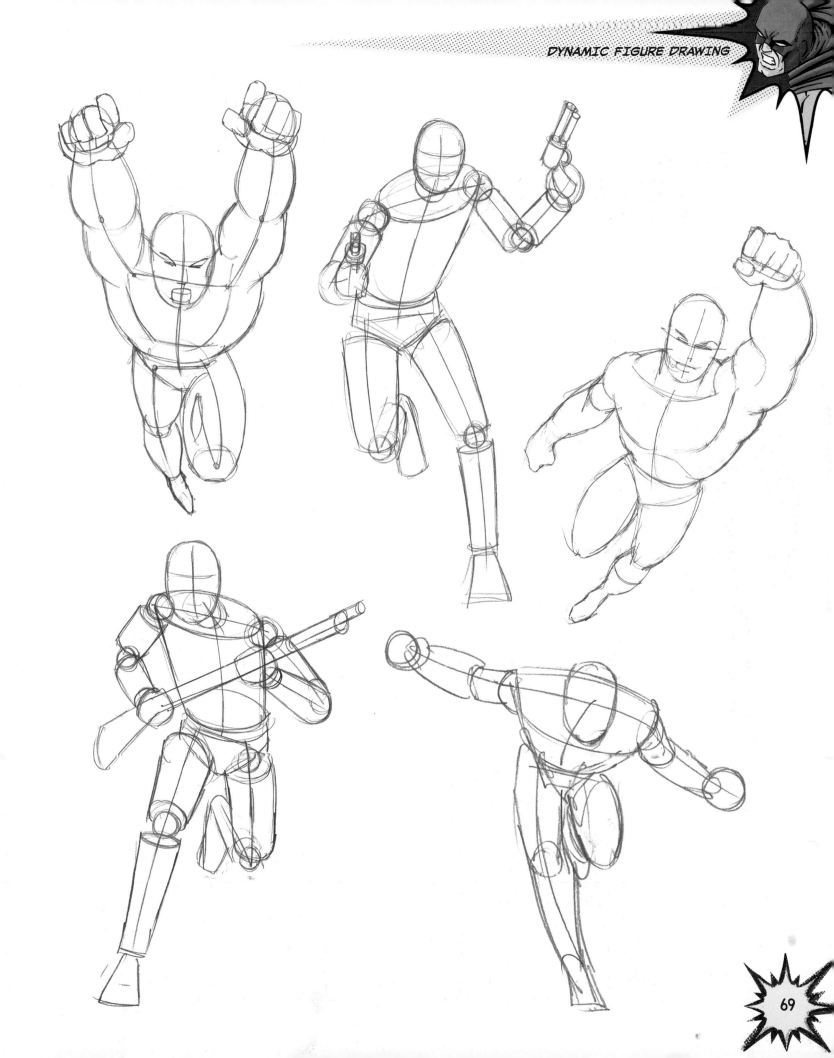

DRAWING A DYNAMIC COMIC BOOK PAGE

Now that we have covered dynamic figure drawing, we can look at how this affects a comic book page.

Not all comic books have to include over-the-top action. Some have a more realistic feel to them, for instance, a crime comic or a human interest story where dynamic action poses may not be required. However, for a comic book page to look exciting, the panels must instantly grab the reader's attention. This can be achieved by adjusting the angle (point of view) of the panel scene. Some panels in a comic may have little or no action in them, so the panels that show the exciting bits of the story need to be used to maximum advantage!

Study the two examples of a comic book page that follow here. They both tell exactly the same story, but are drawn using different points of view. The panels show a superhero flying through the sky over a city. Suddenly there is an explosion below in a building. The hero flies towards the scene of destruction in the hope that he can save lives! Notice how, by adjusting the angle, you can maximize the impact of your panels.

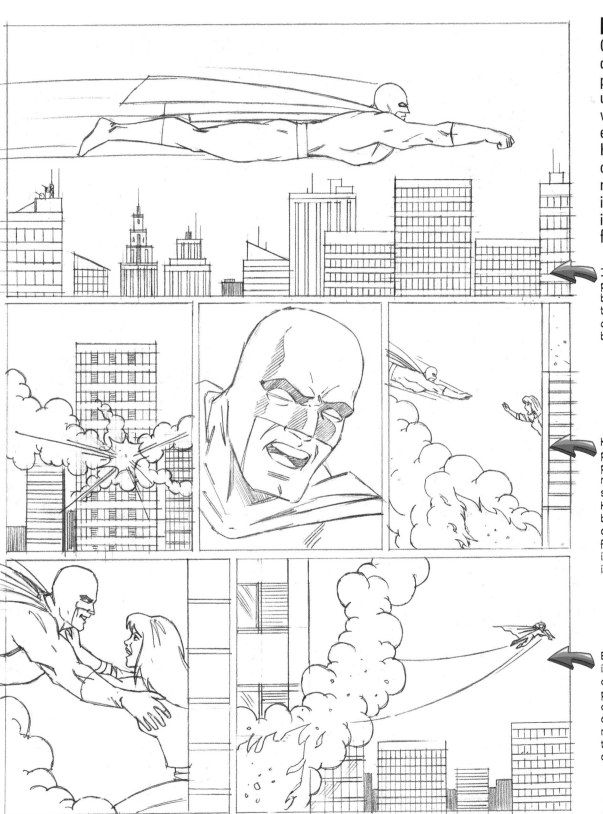

EXAMPLE 1

Okay, here's how not to do it! In example 1, all the panels have been drawn using a very dull point of view. The viewpoint is at eye-level on every panel. Keeping the same point of view for each panel restricts the amount of information you can include and can spoil the flow of your storytelling.

Imagine if all the pages of the comic book were drawn in this way – they would quickly become a bit boring to read.

Keeping the same point of view in every panel means the reader doesn't get a sense of perspective. How tall is the burning building? How far will our damsel in distress fall if she isn't rescued in time? None of this is shown clearly.

Even though the plot is dramatic, the reader doesn't get a clear picture of the impending danger. There is no sense of suspense, which is what makes the reader keep turning the pages to find out how the story ends.

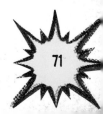

EXAMPLE 2

Wow — what a difference! Here, the point of view in each panel is used to set the pace and flow of the story. This gives a much more exciting view of the action, drawing in and keeping the reader hooked from one panel to the next.

This time the hero has a dynamic pose and we view him flying above the city from a more interesting angle.

Here, we view the explosion from below, keeping the hero in frame so we know he is nearby.

In the next panel, the angle switches to show the hero surveying the scene from above. He has spotted a figure in need of rescue in the burning building.

Now we get a straight-on view at a high level. This shows the reader that our damsel in distress is dangerously high up in the building!

Here we have the hero rescuing the girl from a more exciting viewpoint.

The final panel shows the action from below and we see the girl safe in the arms of the hero. He carries her up and away from the building just as there is another big explosion!

Which of the two versions of this story do you find the most interesting to look at? If you find the panels in example 1 a little boring, it's likely that a reader would also be bored if you drew your comic book in this way.

PENCILLING
A COMIC BOOK PAGE

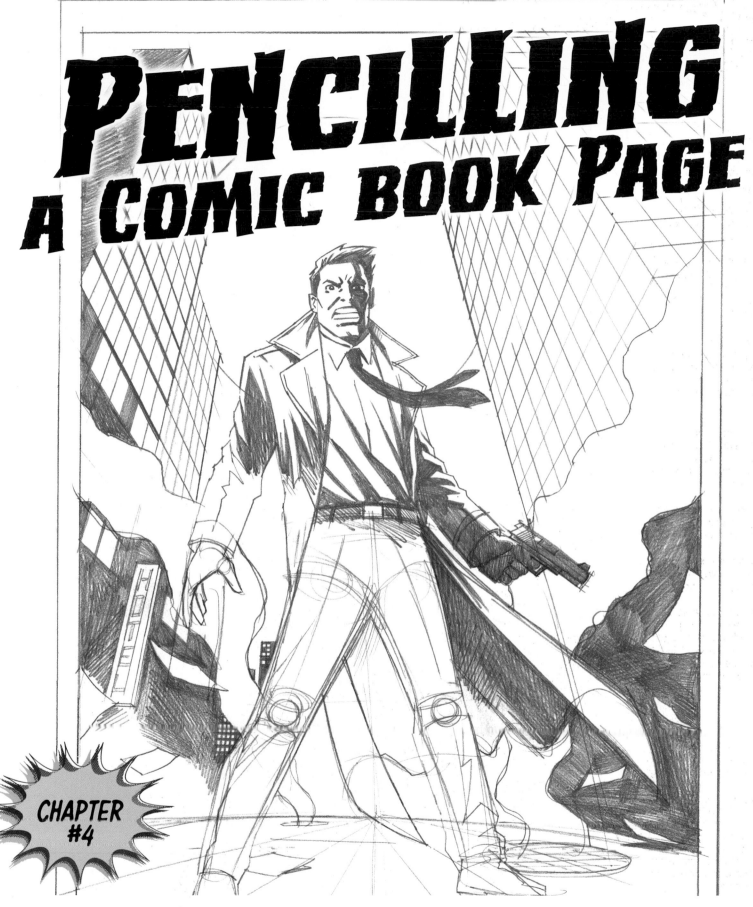

CHAPTER #4

Once you have chosen your characters, setting and plot, the next vital step is learning how to design a comic book page. The key to producing an effective comic book page is to keep the design simple and the action exciting. Your aim is to tell an exciting story in a clear way, while ensuring that the reader finds each panel interesting and powerful. Let's get pencilling!

PAGE CREATION

Before you learn the step-by-step process of pencilling a comic book page, it's a good idea to familiarize yourself with the various elements that can be used to create one. Once you have learnt how these all work together, you'll have all the tools you need to create your own fantastic comic book pages!

Splash Page

There are two different types of comic book page: a splash page (right) and a standard page (far right). A splash page is often used on the first page of a comic book to establish the main character, set the scene and act as an introduction to the story.

A splash page always features a full-page drawing with no additional story panels. It has to look dramatic and exciting to catch the attention, and encourage the reader to delve into the rest of the story.

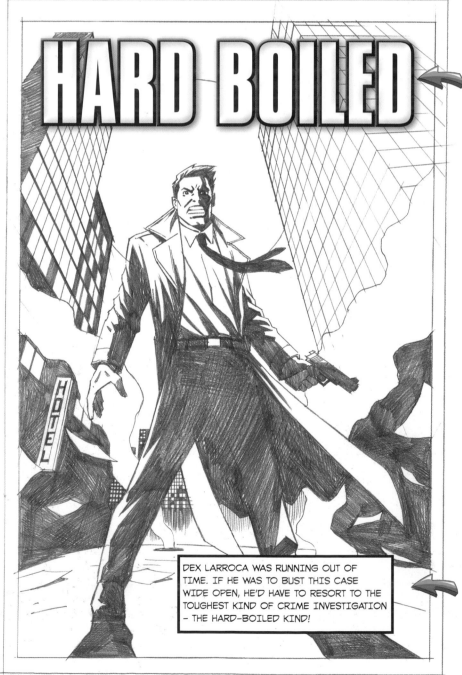

The title of the story appears in huge type, as a banner heading. Letters drawn in outline, like this are called 'open letters'. They're left un-inked so that colour can be added later.

DEX LARROCA WAS RUNNING OUT OF TIME. IF HE WAS TO BUST THIS CASE WIDE OPEN, HE'D HAVE TO RESORT TO THE TOUGHEST KIND OF CRIME INVESTIGATION – THE HARD-BOILED KIND!

Text that talks directly to the reader, rather than appearing in a speech bubble, is called a caption.

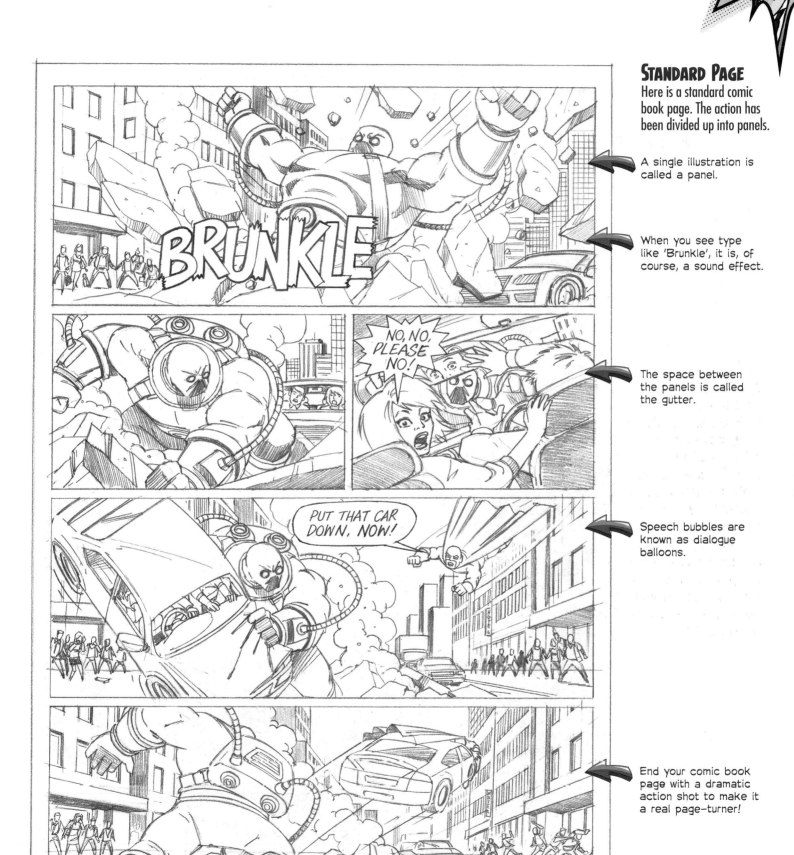

STANDARD PAGE

Here is a standard comic book page. The action has been divided up into panels.

A single illustration is called a panel.

When you see type like 'Brunkle', it is, of course, a sound effect.

The space between the panels is called the gutter.

Speech bubbles are known as dialogue balloons.

End your comic book page with a dramatic action shot to make it a real page-turner!

BRUNKLE

NO, NO, PLEASE NO!

PUT THAT CAR DOWN, NOW!

TYPES OF PANELS

In many ways, planning a comic book is similar to movie making. Even though the action in a comic book is static, you still need to consider the best angle to use for each panel. Similarly, a movie director chooses the position from which his camera will get the most effective shot. Certain angles are more exciting than others and it's up to you to find the ones that will illustrate the plot clearly, while keeping the reader interested. Let's take a closer look at different types of panel, what they are called and why they are used.

This is called a medium shot. The action is viewed from further away, so the reader can see the figures from head to toe.

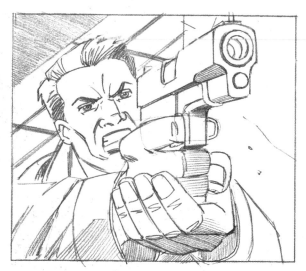

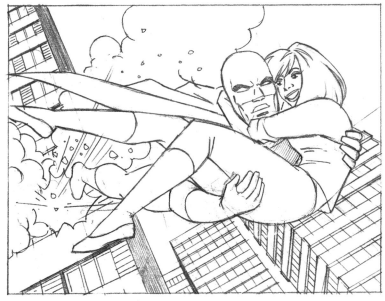

This panel is called a close-up. This is where you zoom in very closely on the action. Close-ups are often used to focus on a character's facial expressions and emotions.

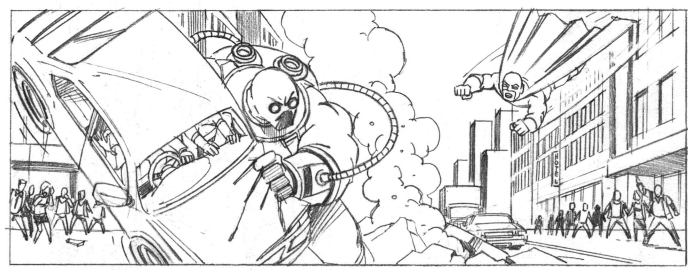

This panel is called a long shot or a panoramic shot. It is used when the story requires a wide-angle shot to include a lot of scenery.

Here is another long shot, but this time the action is seen from above as a 'bird's eye view'.

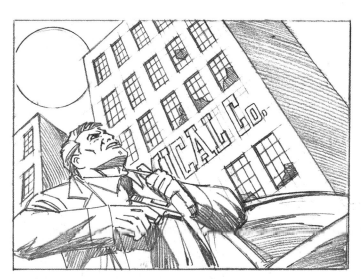

This angle is called 'worm's eye view'. It shows the action from below.

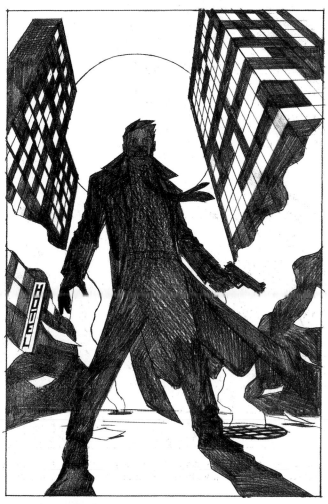

Here, the main details are shown in solid black. This is called a silhouette.

PANEL COMPOSITION

Now that you know about different types of panel and angles, let's move on to composition, which is how you put it all together! Composition, or layout, is a very important part of comic book art. Each panel must be carefully composed so that the story is easy to follow, the action flows nicely and each page is interesting.

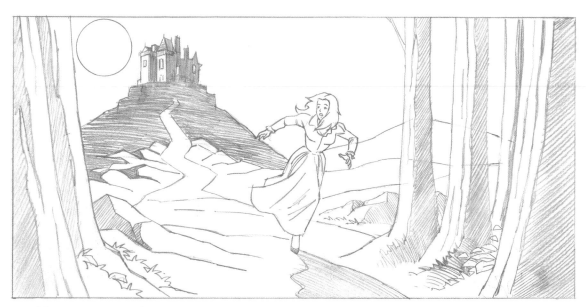

LONG SHOT

This long shot has been chosen to set the scene. It leaves the reader eager to discover who or what the woman is running from and what will happen once the woman enters the woods.

Generally, the reader's brain processes information from left to right. Notice how the elements in this panel flow from left to right – the order in which they should be viewed.

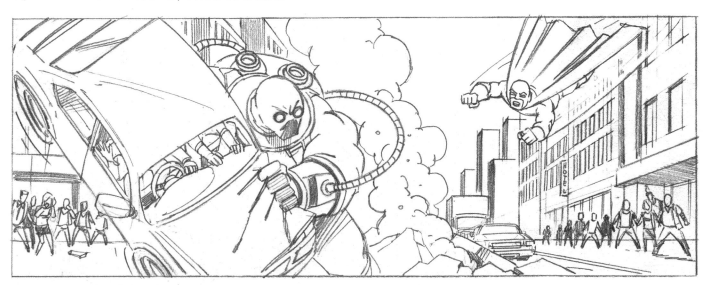

WIDE-ANGLE SHOT

This wide-angle shot is packed with action and information. All the elements work logically so that the reader can immediately understand the story.

A comic book page should be drawn well enough so that it all makes sense without the aid of captions or speech balloons.

78

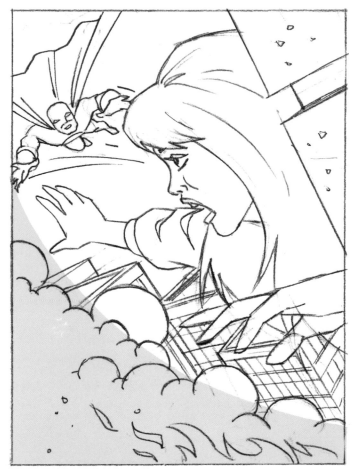

CLOSE-UP
Here is a close-up shot. It's an intense scene where the hero is rushing to save a girl who is trapped in a burning building.

Notice how the main interest is grouped in the top half of the panel. The smoke, below, is used to frame the action.

WIDE-ANGLE SHOT
Here is another wide shot. Notice how the position of the girl's body forms a triangular shape. The forest makes a curve around her.

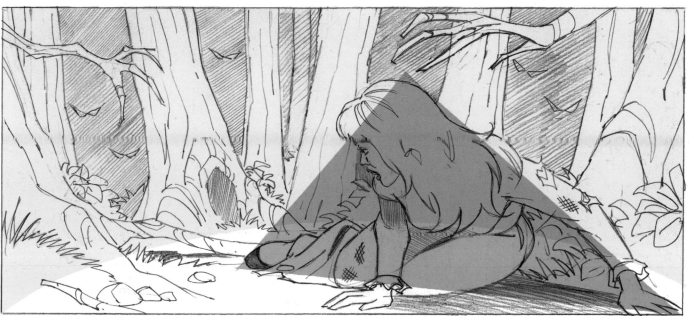

STEP-BY-STEP SUPERHERO STORY

OMEGA MAN VS MANIACAL MONSTER

STEP 1: FIRST DRAFT

The plot: A huge, crazy monster smashes into the middle of a busy city and begins to wreak havoc! Showing his enormous strength, he grabs a nearby car, terrifying its passengers. Just at this moment, a superhero, Omega Man, arrives at the scene, with the sole objective of saving the innocent passengers. The monster sees him coming, turns, and hurls the car (with the passengers still inside) at Omega Man!

This is a good place to halt the story as it makes an exciting page-turner. The reader will want to find out what happens next.

The page opposite shows the first draft. This stage is all about planning the layout to see how the action will flow from panel to panel. The figures are drawn very roughly, first in stick figure form, then built up using construction shapes (spheres, cubes etc.). At this early stage, draw perspective lines so you get the angle of the buildings right, and sketch a rough grid to help you scale the foreground and background objects correctly in relation to one another.

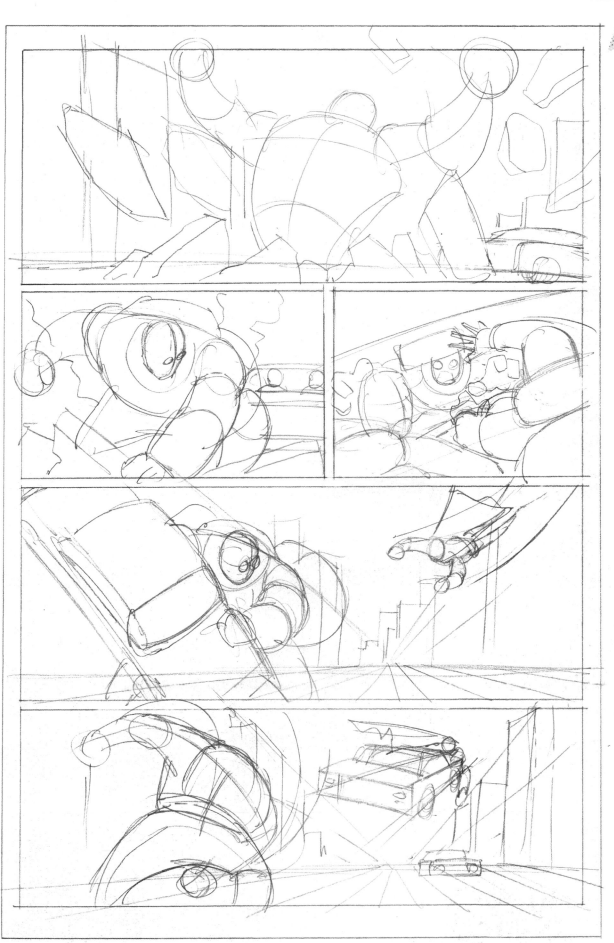

STEP 2: ADDING DETAIL

Start to shape up your figures and add detail. This page is packed with action so keep your figures looking dynamic. Pencil in the figures on the street, and sketch the surrounding buildings and the cars.

Using the perspective lines that you established at the first draft stage, map out the shapes of the buildings and their various heights. Take care to draw in the windows on each building. It's worth taking time to do this, as it will make your buildings look much more realistic. The more time you spend getting all the little details just right, the more believable your drawing will look. If you rush at this stage, you might end up with a drawing that looks too cartoon-like.

Base the cars on real vehicles. In preparation, you could look at some parked cars in your street or neighbourhood and do some sketches. If you base your content on real objects and pay attention to detail, your drawings will look much more realistic and polished.

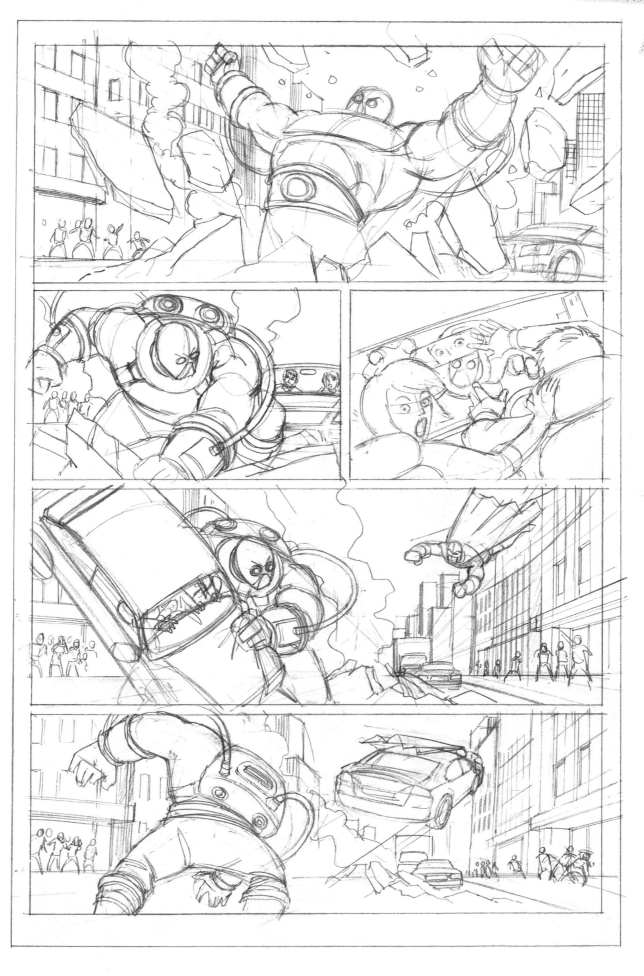

STEP 3: FINAL PENCIL PAGE

Finally, define your pencil work with clean line work. Add the final details and shading, and mark in the areas to be inked in solidly. Shading prevents your drawing from looking flat; gives it depth and makes it look more dynamic.

Look at the finished comic book page, opposite. As you can see, we haven't included any text in this pencil page. This is to demonstrate how, when drawn correctly, a series of panels can clearly tell a story without any dialogue. See opposite for a description of each panel.

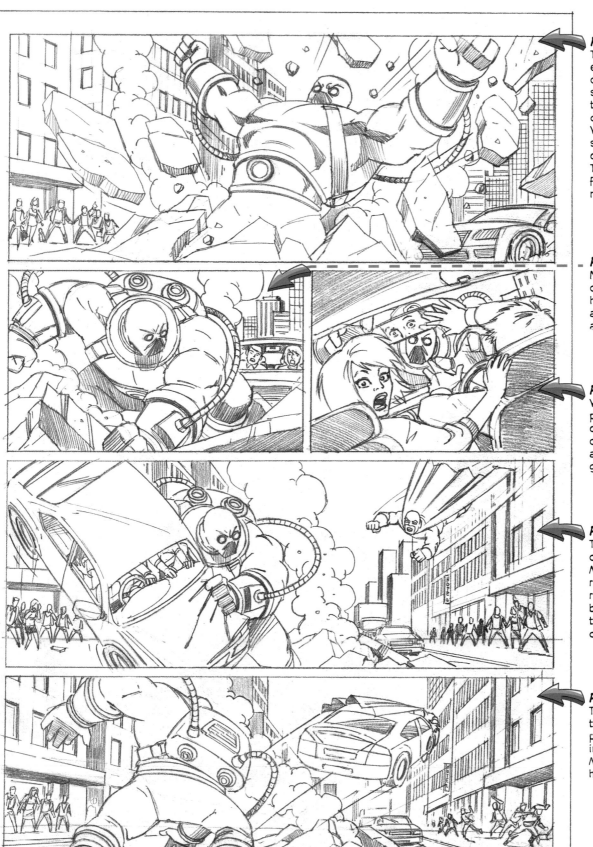

PANEL 1
This shows the entrance of the crazy monster as he smashes up through the road, scattering debris everywhere. We also see a car screeching to a halt on the far right. This is the reader's first sight of the monster's victims.

PANEL 2
Next, the monster climbs out of the hole in the ground and notices the car and its passengers.

PANEL 3
We now switch to the passengers' point of view inside the car, as the monster approaches and grabs the bonnet.

PANEL 4
The monster lifts the car just as Omega Man swoops to the rescue! Notice the reactions of the bystanders – always think about little details like these.

PANEL 5
The monster hurls the car with the passengers still inside at Omega Man. But what happens next?!

STEP-BY-STEP CRIME STORY

HARD BOILED

STEP 1: FIRST DRAFT

The plot: Hard–boiled cop, Dex Larroca, is working on his latest case. He follows a lead to an abandoned warehouse and breaks in to search the building.

This portion of plot makes a good opener. Rough out the story in the panels using simple shapes to establish the composition and content of each one. Consider the different types of panels and what angle will work best for each piece of the action. Remember to keep it simple but exciting!

When you can see things shaping up, pause for a moment and take a look at the whole page. Ensure the story makes sense from panel to panel before you add any detail.

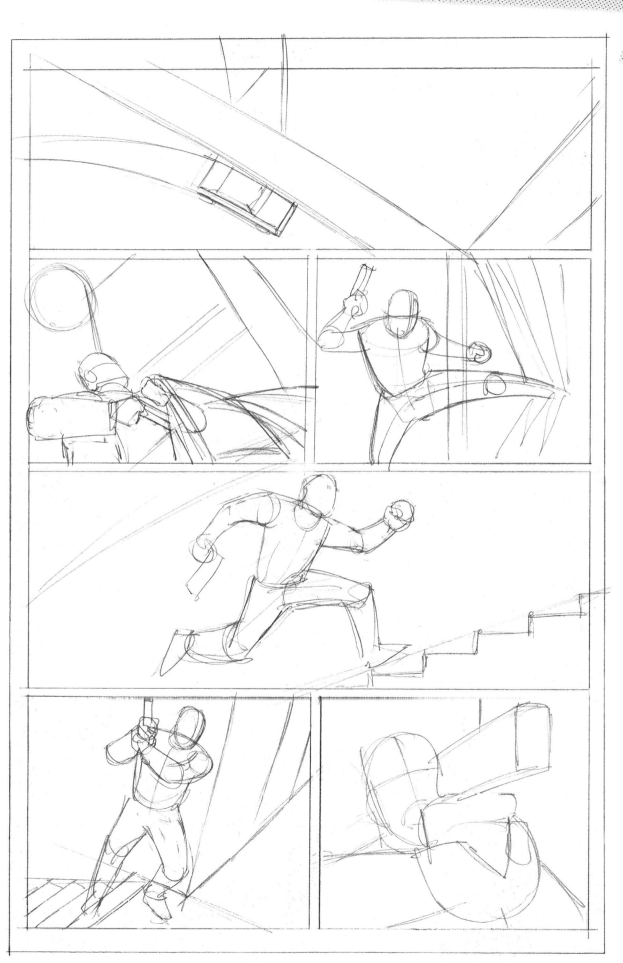

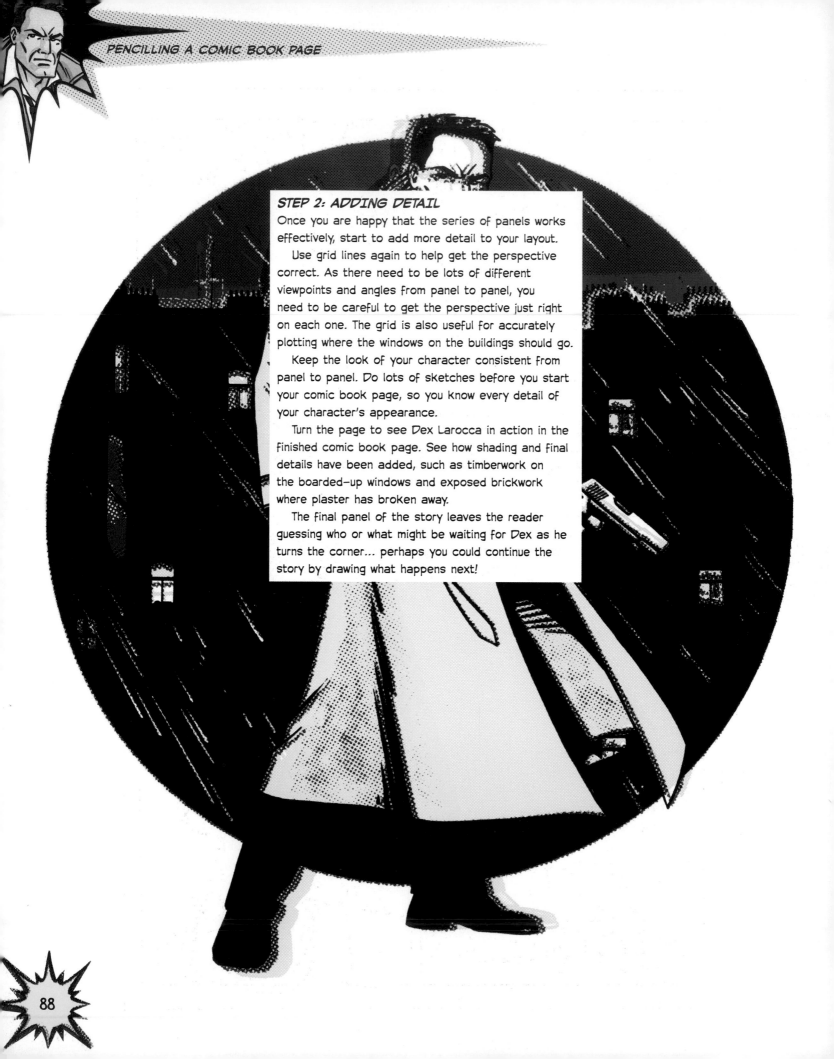

STEP 2: ADDING DETAIL

Once you are happy that the series of panels works effectively, start to add more detail to your layout.

Use grid lines again to help get the perspective correct. As there need to be lots of different viewpoints and angles from panel to panel, you need to be careful to get the perspective just right on each one. The grid is also useful for accurately plotting where the windows on the buildings should go.

Keep the look of your character consistent from panel to panel. Do lots of sketches before you start your comic book page, so you know every detail of your character's appearance.

Turn the page to see Dex Larocca in action in the finished comic book page. See how shading and final details have been added, such as timberwork on the boarded-up windows and exposed brickwork where plaster has broken away.

The final panel of the story leaves the reader guessing who or what might be waiting for Dex as he turns the corner... perhaps you could continue the story by drawing what happens next!

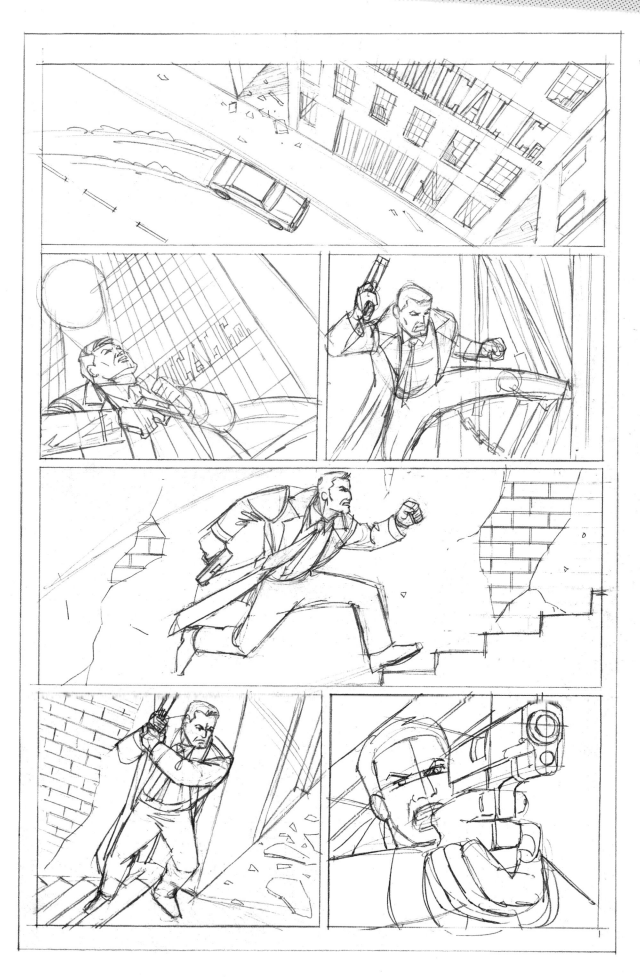

STEP 3: FINAL PENCIL PAGE

PANEL 1
A bird's eye view of Dex pulling up outside the warehouse. This angle is excellent for establishing a location. It makes the reader feel the character is being watched...

PANEL 2
A worm's eye view as Dex prepares to enter the building.

PANEL 3
This is a straight-on medium shot.

PANEL 4
This is a type of wide-angle medium shot.

PANEL 5
Again, this angle suggests that Dex may be being secretly observed by someone outside the panel. This creates extra suspense and a feeling of unease in the reader.

PANEL 6
Finally, we cut to an intense close-up as Dex turns the corner.

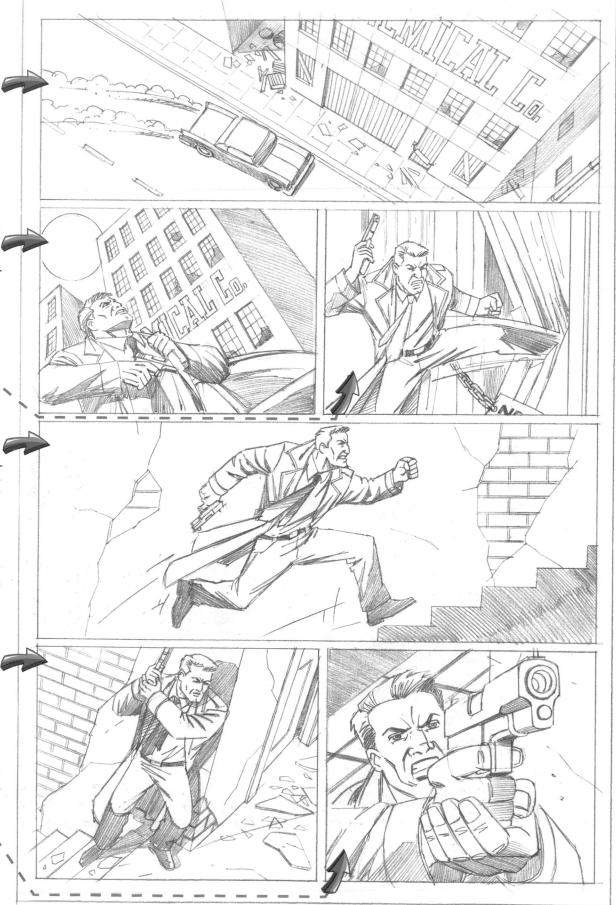

90

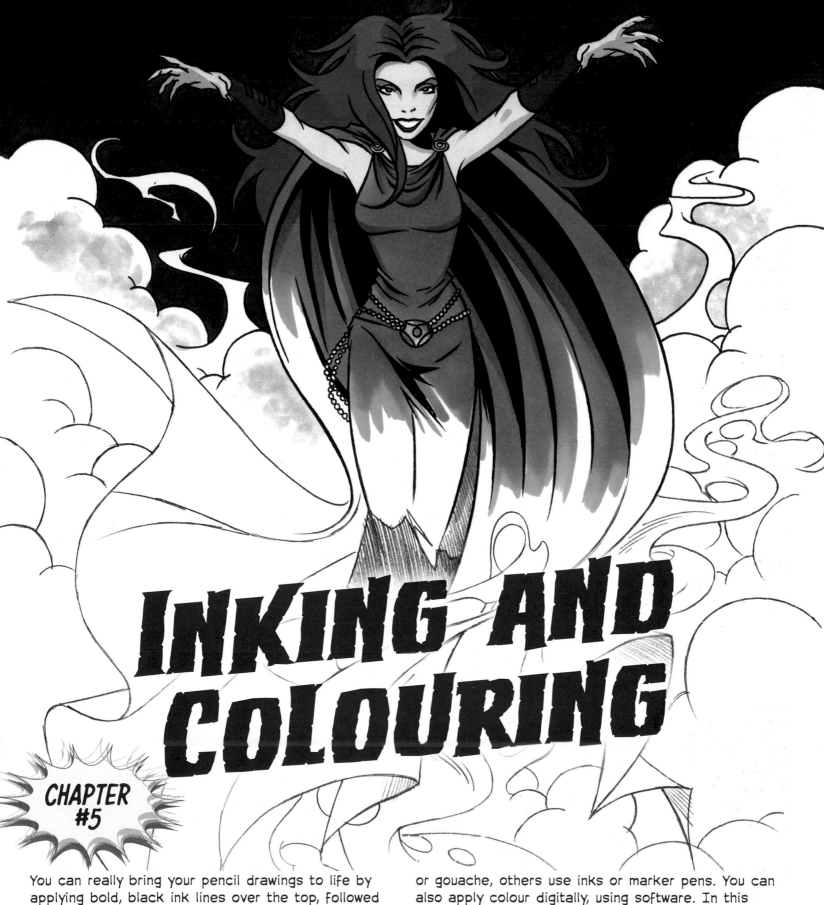

INKING AND COLOURING

You can really bring your pencil drawings to life by applying bold, black ink lines over the top, followed by vibrant colours. There are lots of ways in which you can apply colour. Some artists use watercolours or gouache, others use inks or marker pens. You can also apply colour digitally, using software. In this chapter we'll teach you a colouring method that can be used with inks, marker pens and watercolours.

INKING AND COLOURING STEPS

EXAMPLE 1: MARTIAL ARTIST

A clean, crisp line style has been used to ink this character, but you may wish to experiment with different styles and textures of your own. Colour has been applied in layers for a rich, tonal finish.

There are a number of ways to ink your pencil drawing. Some artists prefer to use a brush and a pot of black Indian ink. We recommend that you use watertight Indian ink to ink your pencil drawings, so that when you apply your colour on top, your ink will not raise or smudge. If you decide to use a brush, a #3 sable brush can be used to achieve a variety of line thicknesses.

There are also lots of good inking pens available, with a range of nib thicknesses, including 'superfine', 'fine' and 'brush'. The 'brush' nib pens are very good as they produce a good range of line thicknesses too (see below).

Once you have inked your drawing, it's time to move on to the colouring. On the following pages we'll show you how to build up layers of colour on top of your inked drawing. The key is to start by applying lighter colours as your base, then building up the colour by adding layers of darker tones over the top.

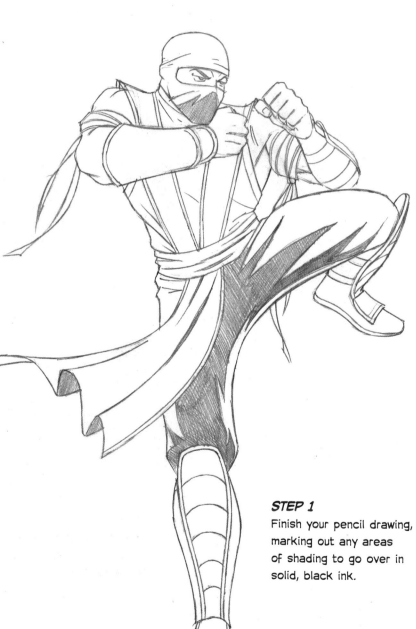

STEP 1
Finish your pencil drawing, marking out any areas of shading to go over in solid, black ink.

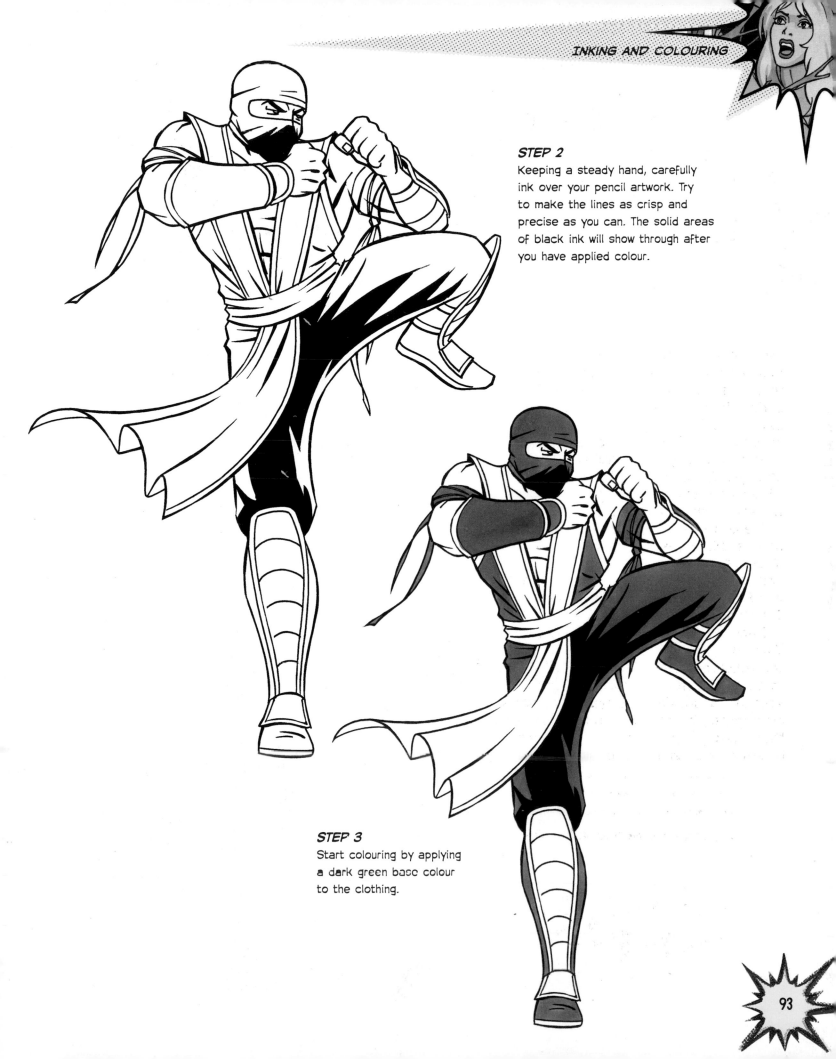

STEP 2

Keeping a steady hand, carefully ink over your pencil artwork. Try to make the lines as crisp and precise as you can. The solid areas of black ink will show through after you have applied colour.

STEP 3

Start colouring by applying a dark green base colour to the clothing.

93

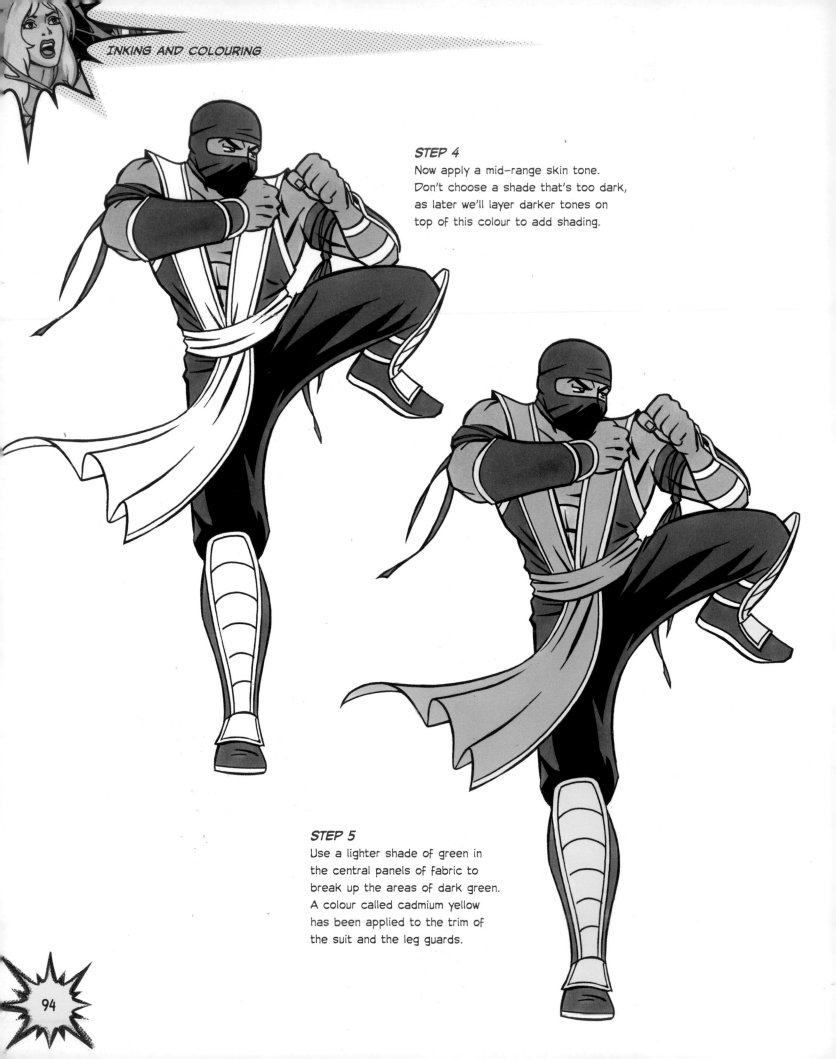

STEP 4

Now apply a mid-range skin tone.
Don't choose a shade that's too dark,
as later we'll layer darker tones on
top of this colour to add shading.

STEP 5

Use a lighter shade of green in
the central panels of fabric to
break up the areas of dark green.
A colour called cadmium yellow
has been applied to the trim of
the suit and the leg guards.

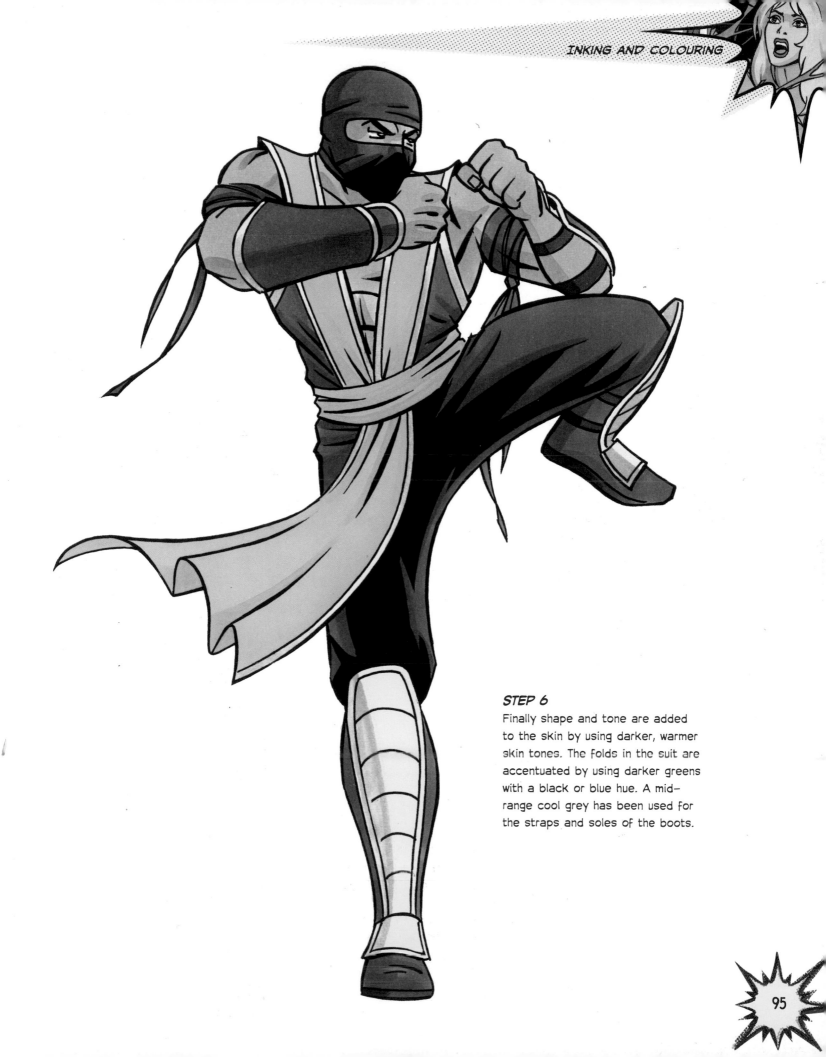

STEP 6
Finally shape and tone are added to the skin by using darker, warmer skin tones. The folds in the suit are accentuated by using darker greens with a black or blue hue. A mid-range cool grey has been used for the straps and soles of the boots.

EXAMPLE 2: BLUE LIGHTNING

There are no solid black areas in this drawing as we want the end result to be light and colourful. Keep the line work delicate to give the figure a soft, feminine feel.

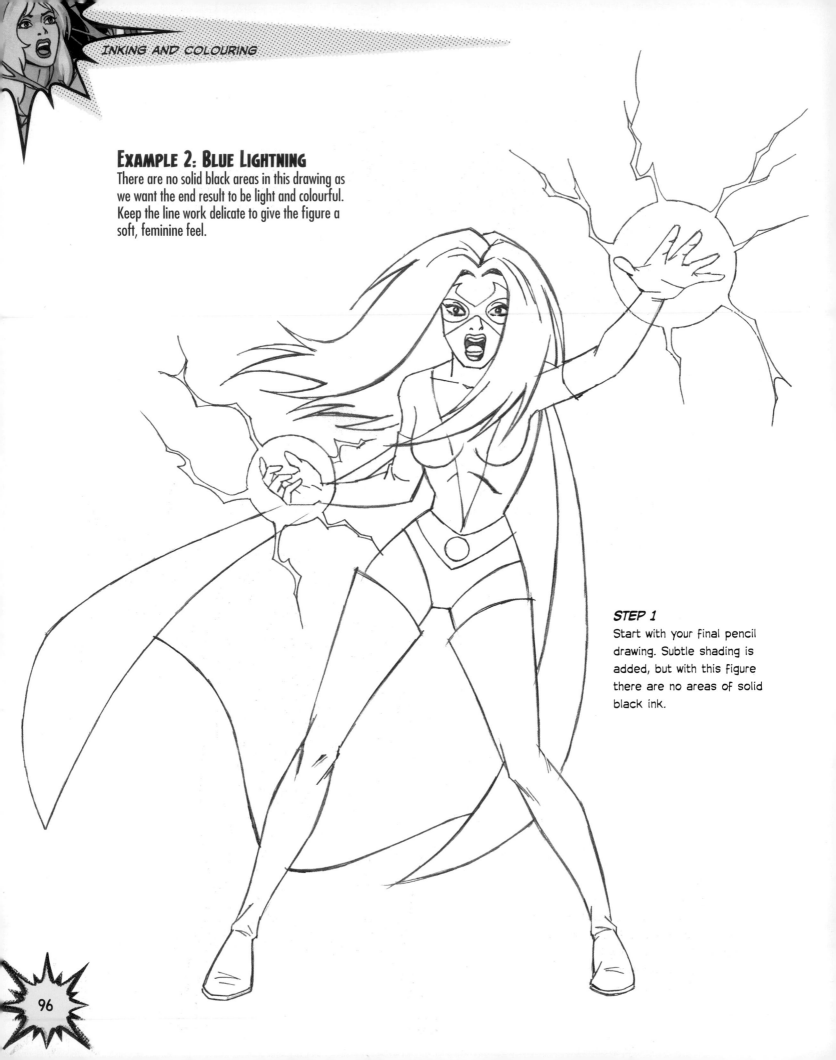

STEP 1

Start with your final pencil drawing. Subtle shading is added, but with this figure there are no areas of solid black ink.

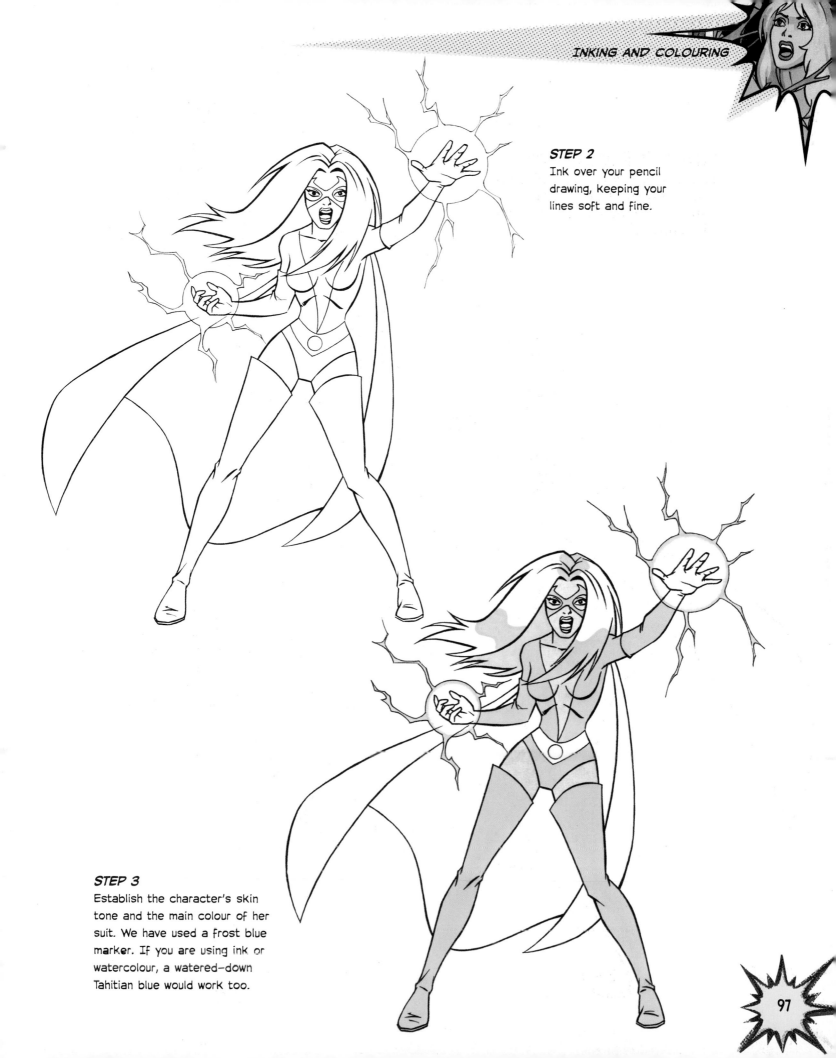

STEP 2

Ink over your pencil drawing, keeping your lines soft and fine.

STEP 3

Establish the character's skin tone and the main colour of her suit. We have used a frost blue marker. If you are using ink or watercolour, a watered-down Tahitian blue would work too.

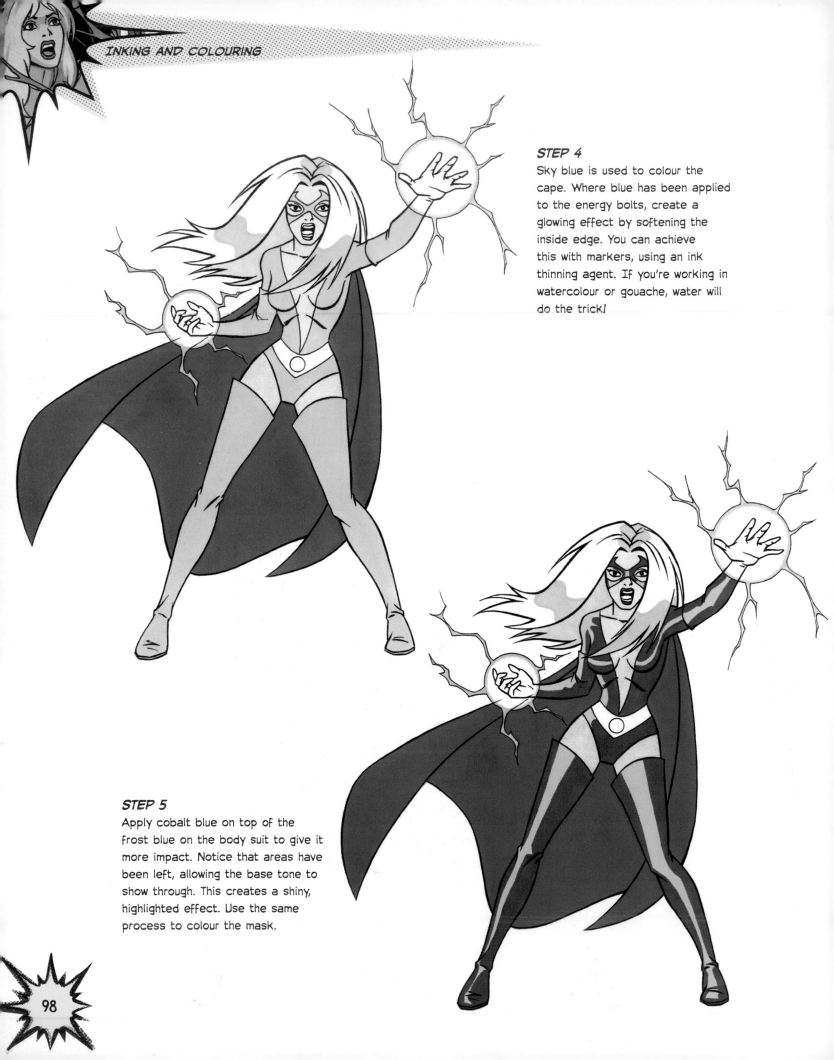

STEP 4

Sky blue is used to colour the cape. Where blue has been applied to the energy bolts, create a glowing effect by softening the inside edge. You can achieve this with markers, using an ink thinning agent. If you're working in watercolour or gouache, water will do the trick!

STEP 5

Apply cobalt blue on top of the frost blue on the body suit to give it more impact. Notice that areas have been left, allowing the base tone to show through. This creates a shiny, highlighted effect. Use the same process to colour the mask.

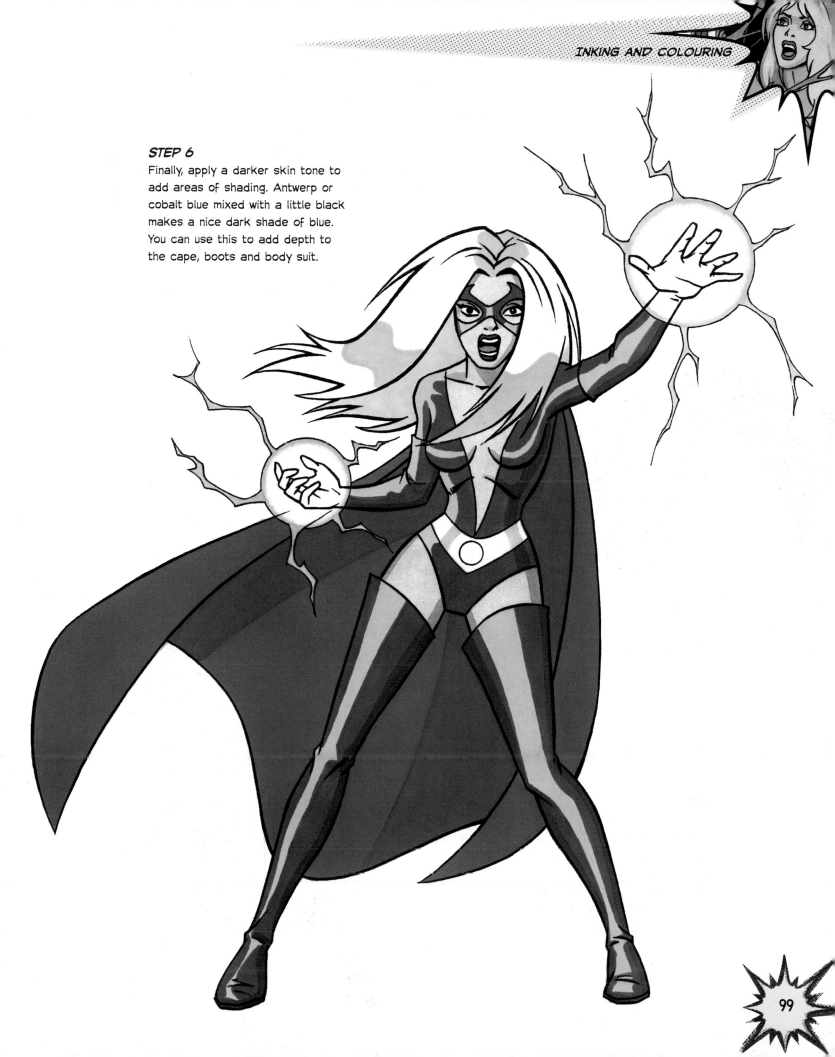

STEP 6
Finally, apply a darker skin tone to add areas of shading. Antwerp or cobalt blue mixed with a little black makes a nice dark shade of blue. You can use this to add depth to the cape, boots and body suit.

EXAMPLE 3: MANIACAL MONSTER

This character is finished using a variety of different line thicknesses and layers of colour. These techniques give the monster a dramatic, three-dimensional apprearance.

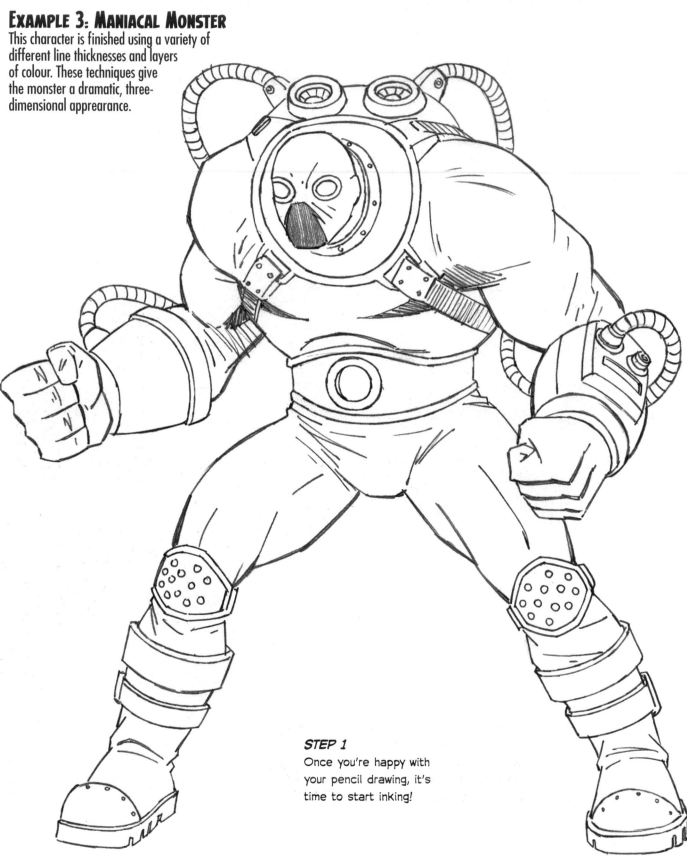

STEP 1
Once you're happy with your pencil drawing, it's time to start inking!

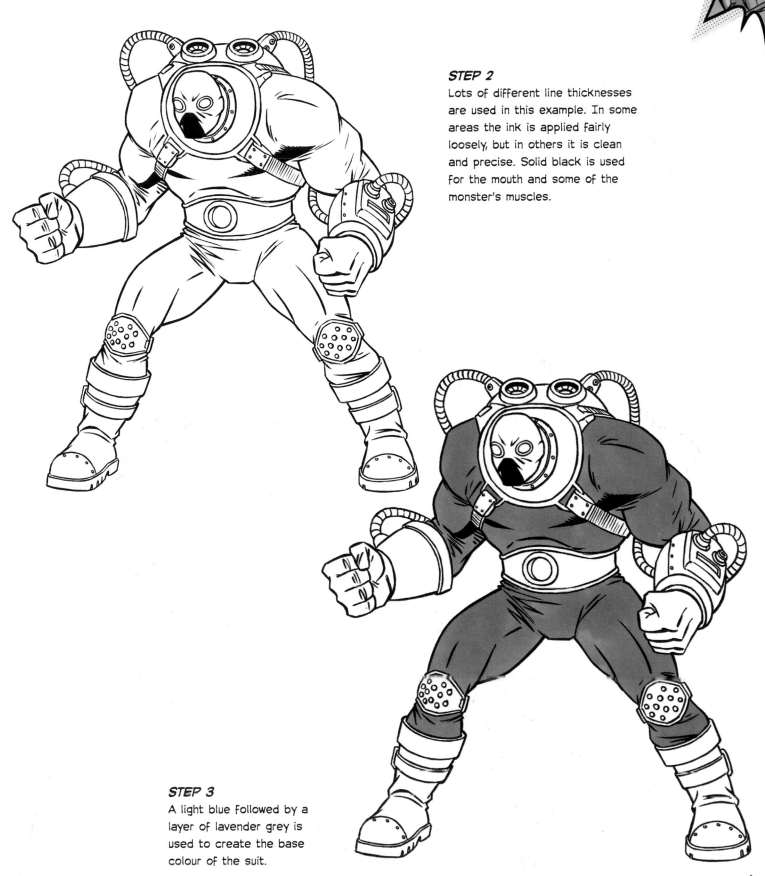

STEP 2

Lots of different line thicknesses are used in this example. In some areas the ink is applied fairly loosely, but in others it is clean and precise. Solid black is used for the mouth and some of the monster's muscles.

STEP 3

A light blue followed by a layer of lavender grey is used to create the base colour of the suit.

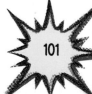

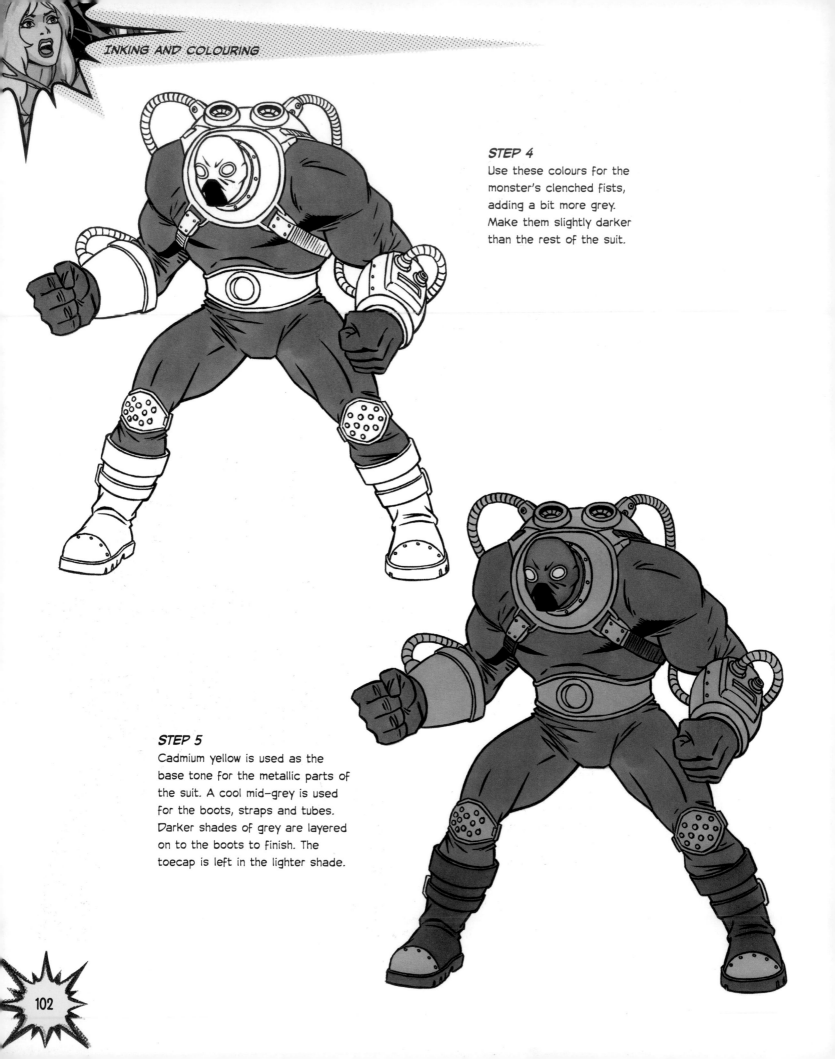

STEP 4

Use these colours for the monster's clenched fists, adding a bit more grey. Make them slightly darker than the rest of the suit.

STEP 5

Cadmium yellow is used as the base tone for the metallic parts of the suit. A cool mid-grey is used for the boots, straps and tubes. Darker shades of grey are layered on to the boots to finish. The toecap is left in the lighter shade.

STEP 6
Sandy shades and orangey-browns
are used to strengthen and add
depth to the metallic areas.

STEP 7
The same cool mid-grey
is applied to add tonal
shading to most of the
suit. Darker shades are
then layered on top to
add muscle tone.

STEP 8
Finally, white highlights are
added to the metallic parts of
the suit and the darker areas
of shading are accentuated.
This guy is ready for action!

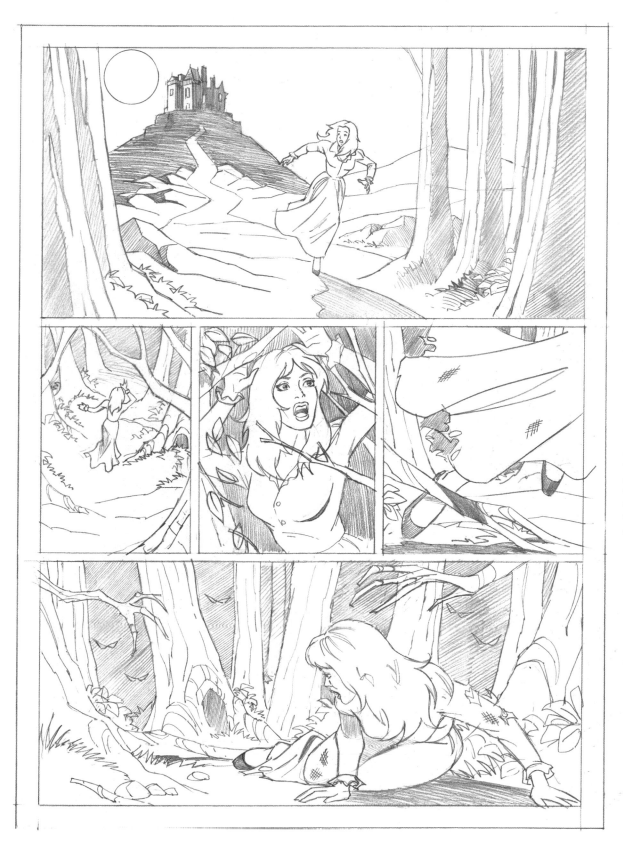

INKING AND COLOURING A COMIC BOOK PAGE

Now that you've learnt how to ink and colour your character drawings, how about tackling a full page of comic book art? It's really not that difficult and the same principles apply.

Here we have a page of comic book art in pencil. The solid areas of shading are marked in at the pencil stage, so it's just a case of inking faithfully over the pencil lines.

This artwork would work equally well with even more inked shading. This would create a stronger contrast between the light and dark areas, but it would leave less room for colour.

As you follow the step-by-step sequence you'll see how the areas of ink and colour work together in the panels, just as they do when you're colouring an individual figure.

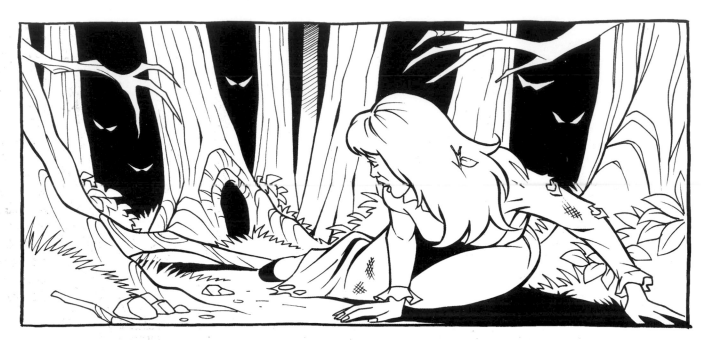

FIG. 1

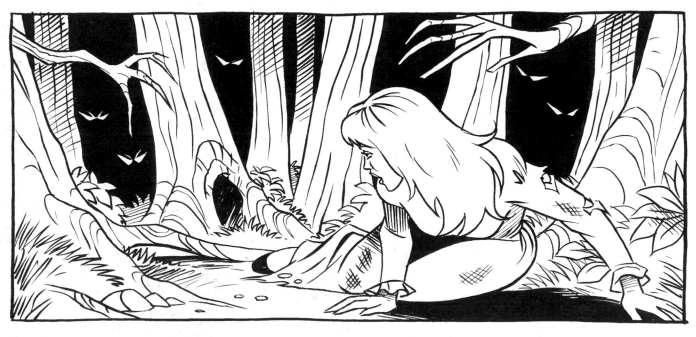

FIG. 2

INKING STYLES FOR PANELS
Some artists like to ink the panel outlines freehand, without the aid of a ruler. This creates a nice contrast between the panel edge and the clean, crisp lines within the panel (above, Fig. 1). You can also use a loose line style inside the panel for a slightly sketchier finish (above, Fig. 2).

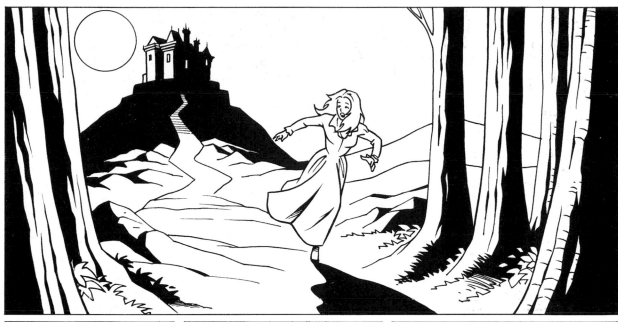

INKED PAGE

So here it is — our fully inked comic book page. When you're creating your own comic book art, you could just choose to keep things simple and leave your artwork in black and white, but the addition of colour will really bring your comic book pages to life, as you'll see on the following page!

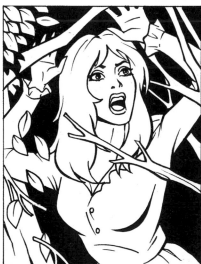

You can see we have kept the line style clean and precise throughout.

Very little shading has been added, so that we have plenty of space left in which to apply colour.

The solid areas of black create dramatic blocks of dark shading. We will also use layers of colour to determine areas of light and shade in the final version.

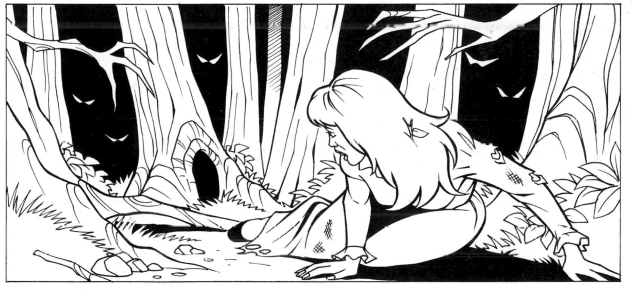

COLOUR PAGE

When colouring your comic book page, choose colours that help show what time of day it is. This story is set a night and the light source is the moon. To achieve a moonlit effect, use light blue as your base colour on all panels.

In panel 1 we establish that the light source is the moon. On top of the light blue, layers of olive green and cool grey are applied to colour the trees.

Pale blue, olive and grey are also used for panels 2, 3 and 4. The girl's skin tone and hair are coloured brightly, making her the focal point. Cool grey is used to add shading to her skin, hair and dress.

In the final panel notice how we have allowed moonlit areas of pale blue to show through on the trees and grass, keeping our light source consistent. The disembodied eyes in the forest are left in white.

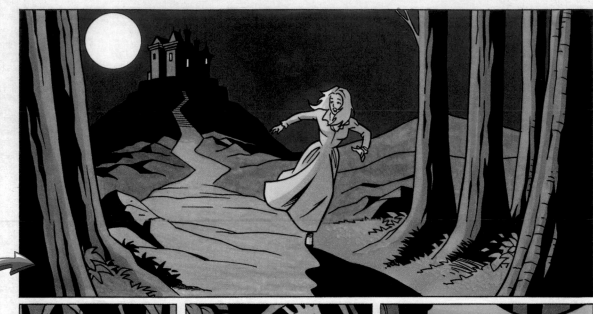

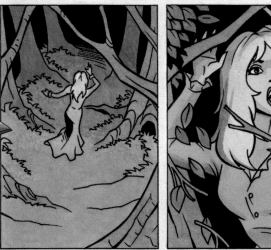
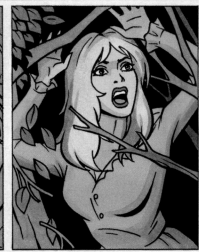

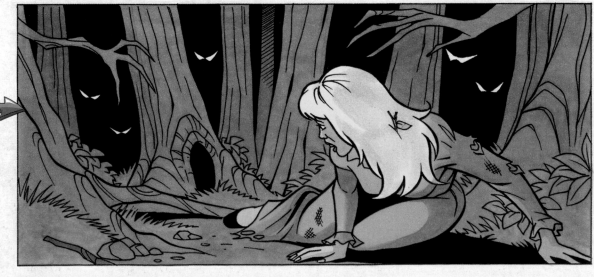

Ready to ink and colour your own fantastic comic book art? We used markers to colour the page above, but a similar effect could be achieved using watercolours or liquid inks. Plan your colour palette before you start to apply any colour, and keep it simple!

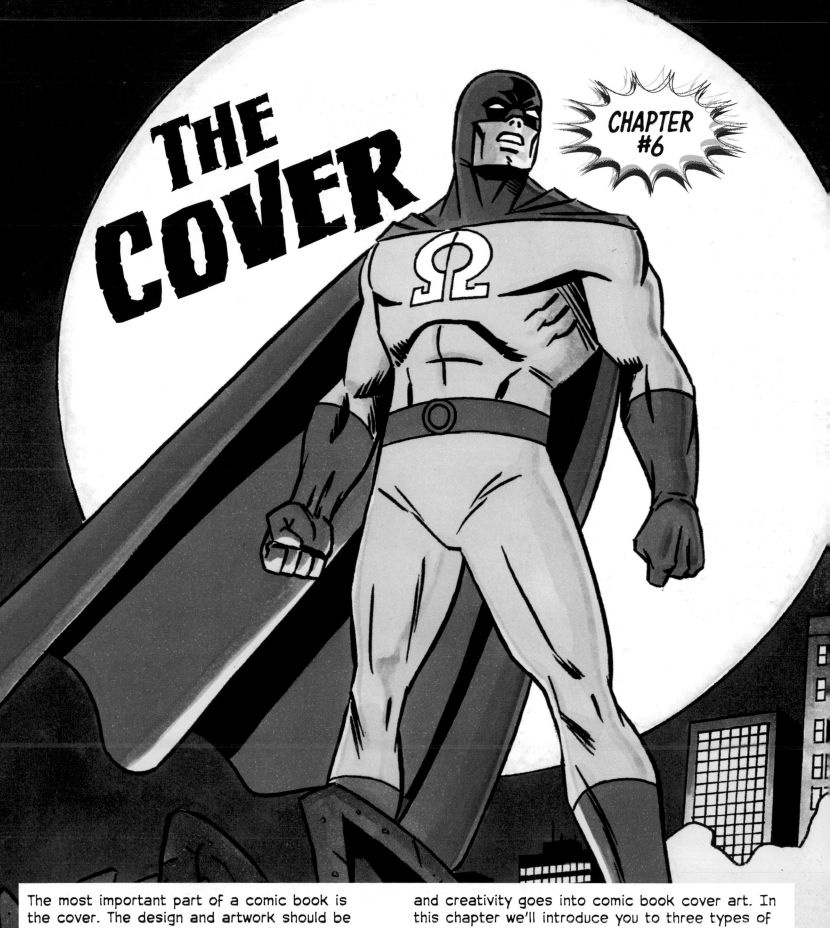

THE COVER

CHAPTER #6

The most important part of a comic book is the cover. The design and artwork should be strong and eye-catching enough to attract the attention of the buyer. A great deal of thought and creativity goes into comic book cover art. In this chapter we'll introduce you to three types of cover, each with a different approach: the hero cover, the story cover and the teaser cover.

THE HERO COVER

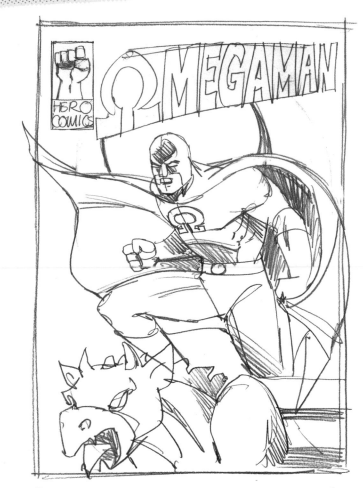

The hero cover always shows the hero from the title of the comic book in a classic hero pose. This type of cover should not reveal too much about the plot to the potential reader but should serve more as an introduction to the main character. In our example, the hero (Omega Man) is standing on a rooftop, surveying the city. We can immediately tell he is strong, brave and ready for action. This type of cover design is often used for first issue covers.

An early stage of the design process is the production of 'thumbnail roughs'. These are small, rough sketches and layouts of potential cover designs. The reason they are drawn so small (usually about 12 centimetres/4.7 inches tall) is to enable the artist to try out a number of possibilities in a short space of time before drawing the final piece of artwork.

On the right are thumbnail sketches showing two options for our hero cover. On the facing page you can see the final pencil drawing of the chosen cover, which is a combination of the two thumbnail designs. The most effective elements from each were chosen for maximum impact.

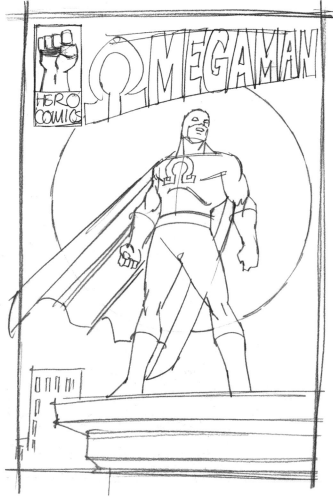

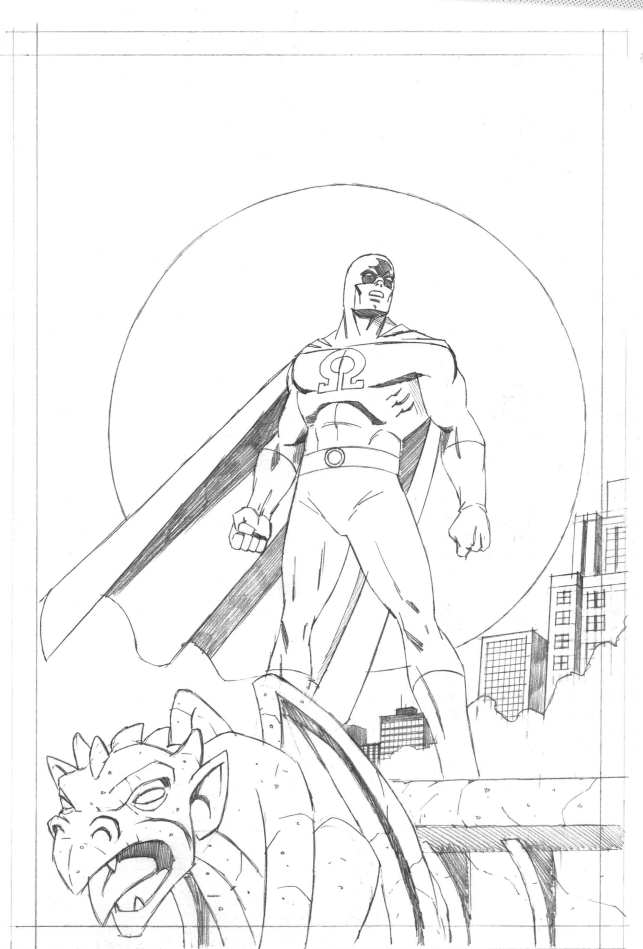

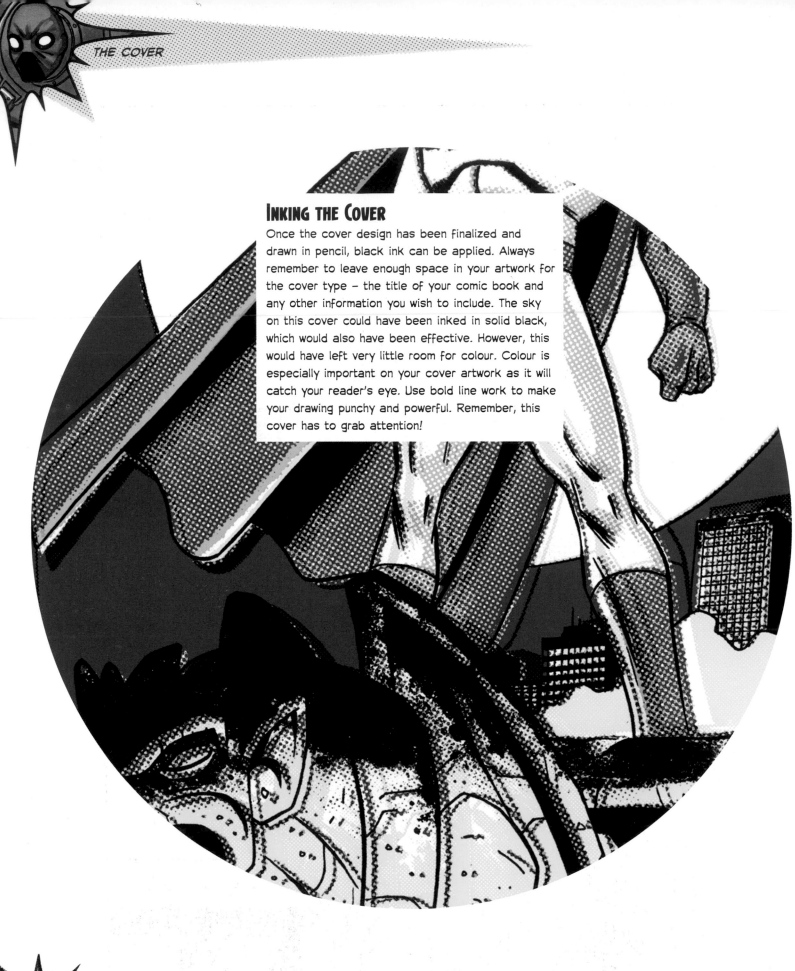

INKING THE COVER

Once the cover design has been finalized and drawn in pencil, black ink can be applied. Always remember to leave enough space in your artwork for the cover type – the title of your comic book and any other information you wish to include. The sky on this cover could have been inked in solid black, which would also have been effective. However, this would have left very little room for colour. Colour is especially important on your cover artwork as it will catch your reader's eye. Use bold line work to make your drawing punchy and powerful. Remember, this cover has to grab attention!

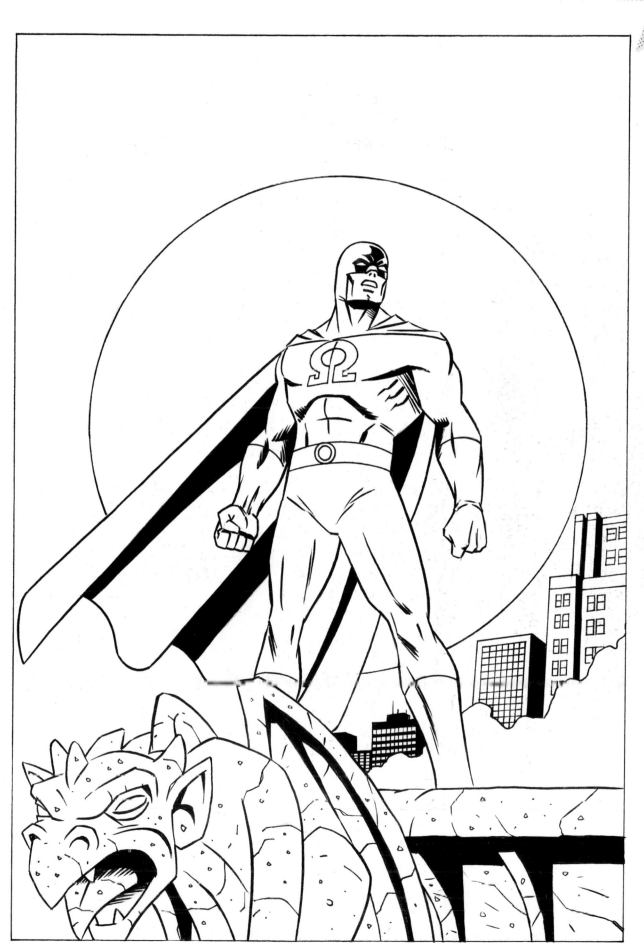

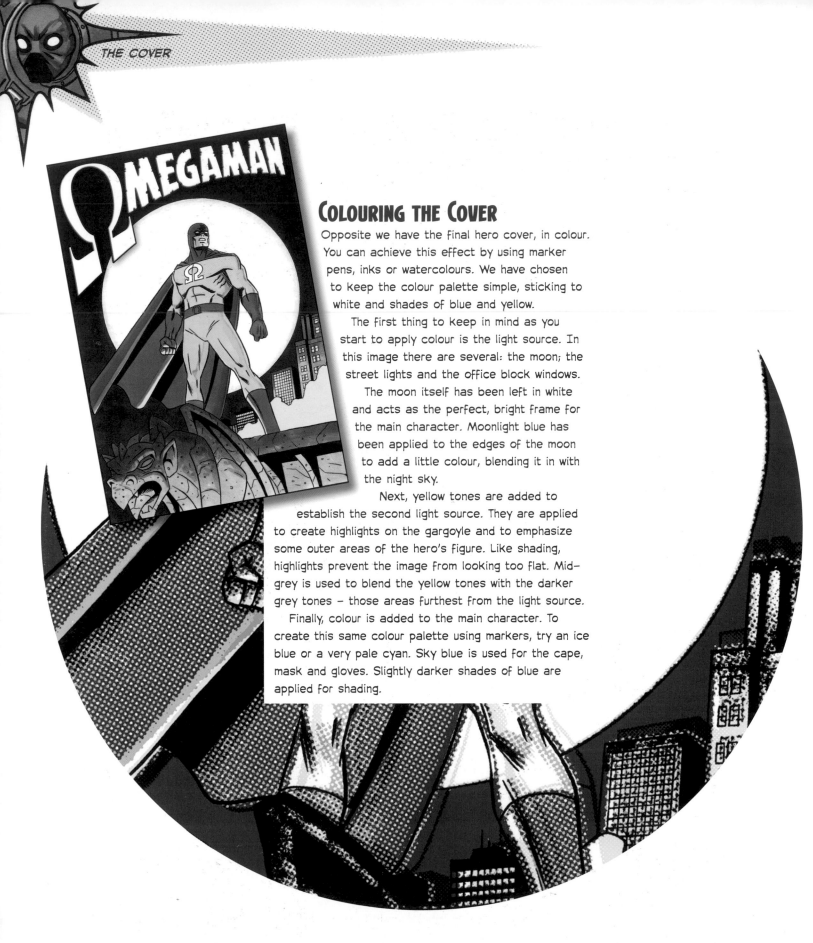

COLOURING THE COVER

Opposite we have the final hero cover, in colour. You can achieve this effect by using marker pens, inks or watercolours. We have chosen to keep the colour palette simple, sticking to white and shades of blue and yellow.

The first thing to keep in mind as you start to apply colour is the light source. In this image there are several: the moon; the street lights and the office block windows.

The moon itself has been left in white and acts as the perfect, bright frame for the main character. Moonlight blue has been applied to the edges of the moon to add a little colour, blending it in with the night sky.

Next, yellow tones are added to establish the second light source. They are applied to create highlights on the gargoyle and to emphasize some outer areas of the hero's figure. Like shading, highlights prevent the image from looking too flat. Mid-grey is used to blend the yellow tones with the darker grey tones – those areas furthest from the light source.

Finally, colour is added to the main character. To create this same colour palette using markers, try an ice blue or a very pale cyan. Sky blue is used for the cape, mask and gloves. Slightly darker shades of blue are applied for shading.

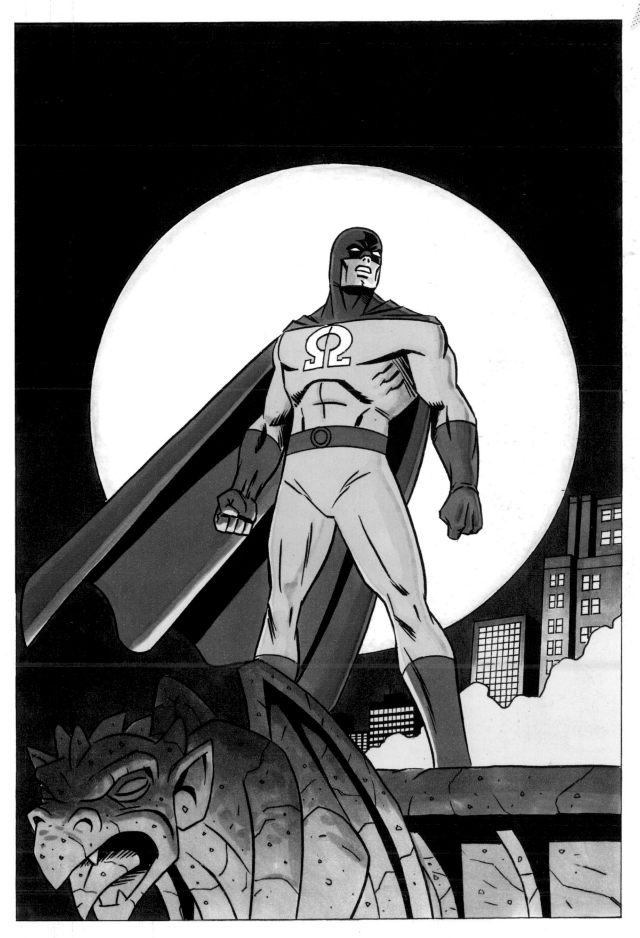

THE STORY COVER

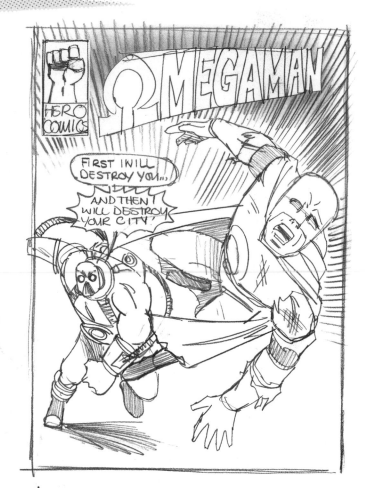

The story cover attracts the attention of the reader by giving a glimpse of the story inside the comic book. Usually, it's the most exciting part of the plot that makes it on to this type of cover. For example, it might show the hero in the clutches of his arch rival, or in the middle of a daring rescue attempt! The story cover uses these exciting bits of the action to entice the reader into buying the comic book, to find out if the hero survives and manages to save the day.

On the right are some story cover thumbnails and on the facing page is the final pencil drawing of the chosen cover. In our example, a supervillain has seemingly defeated the hero. Showing the hero in a near-death situation always makes an exciting comic book cover.

Layout and composition are very important. In our final cover drawing, the hero has been deliberately made to look small and lifeless in comparison to the maniacal monster. Will Omega Man survive to fight another day? This type of dramatic cover makes the reader eager to buy the comic book to find out what happens next!

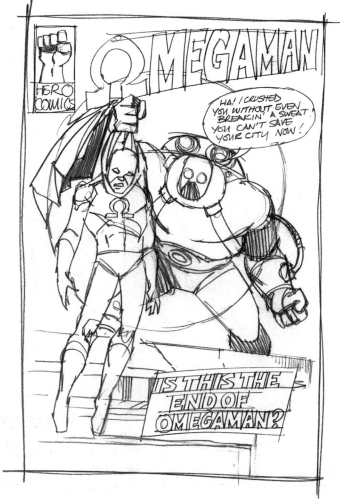

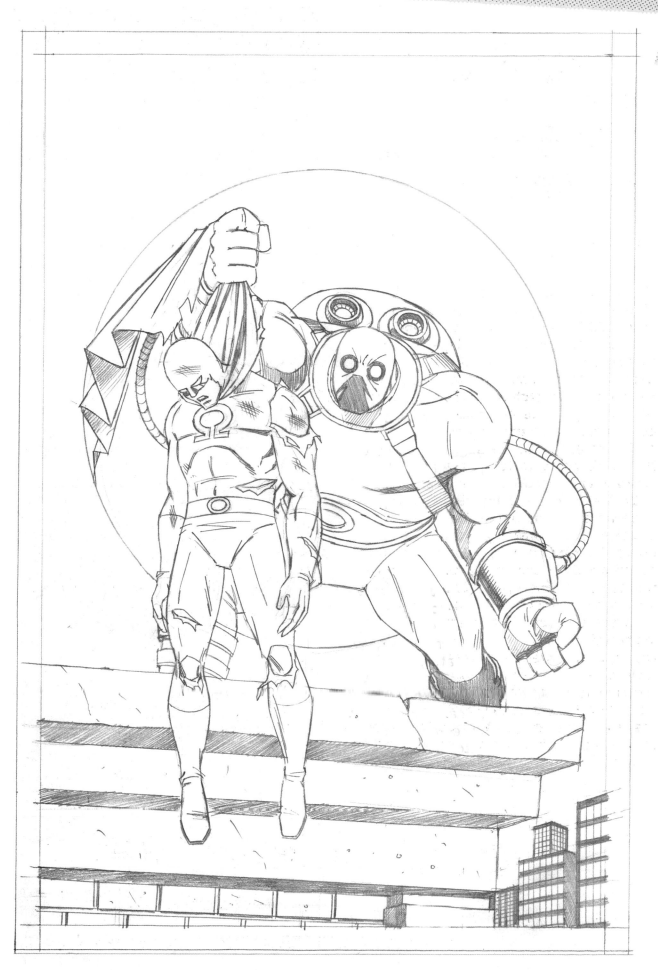

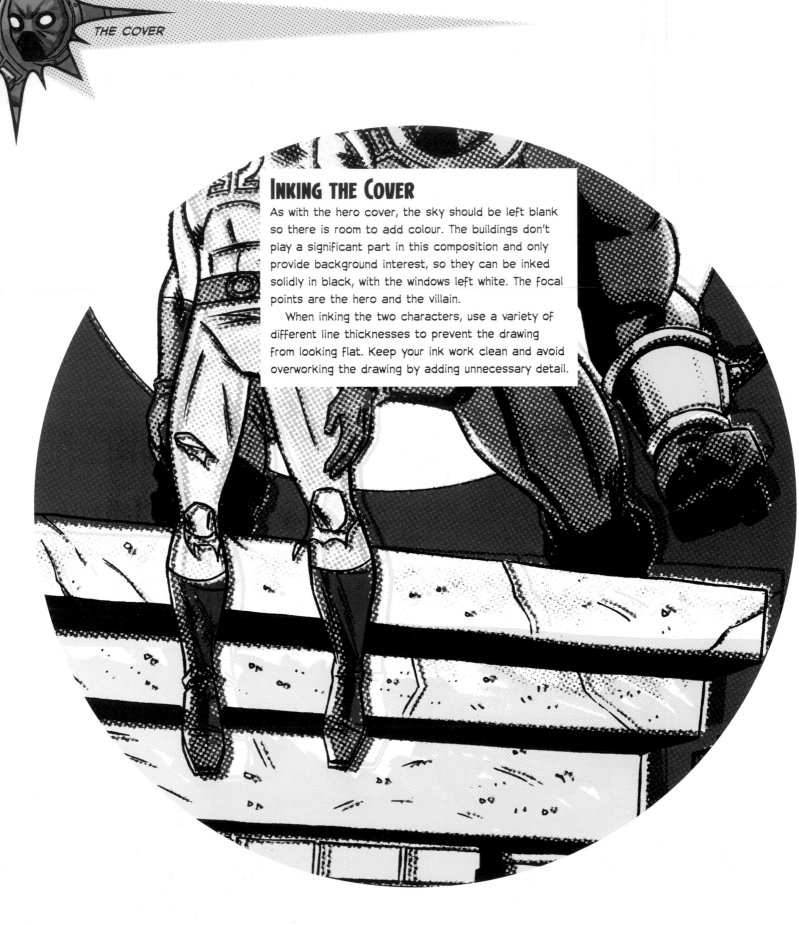

INKING THE COVER

As with the hero cover, the sky should be left blank so there is room to add colour. The buildings don't play a significant part in this composition and only provide background interest, so they can be inked solidly in black, with the windows left white. The focal points are the hero and the villain.

When inking the two characters, use a variety of different line thicknesses to prevent the drawing from looking flat. Keep your ink work clean and avoid overworking the drawing by adding unnecessary detail.

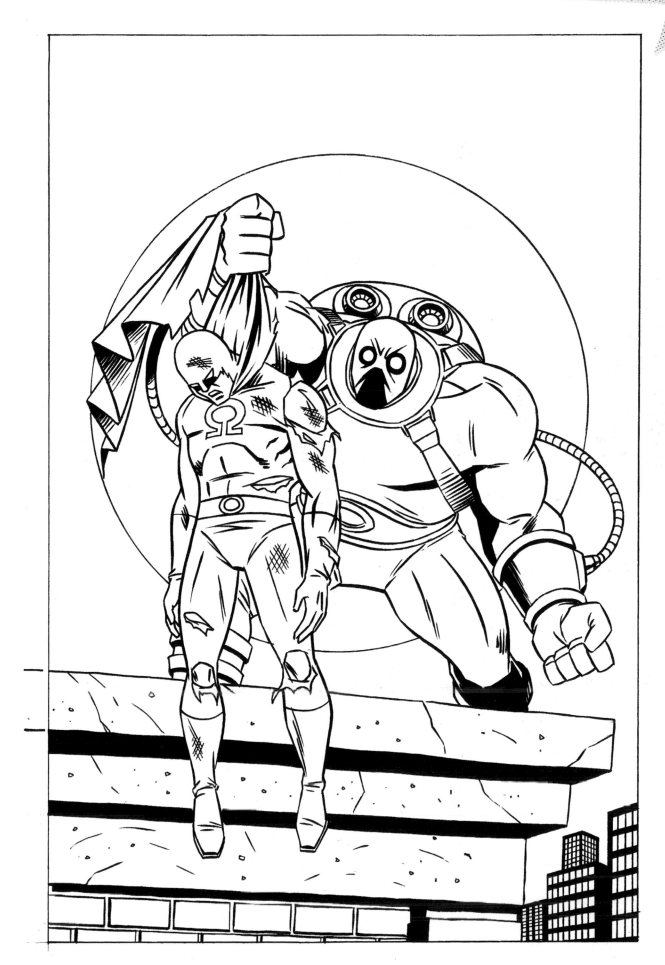

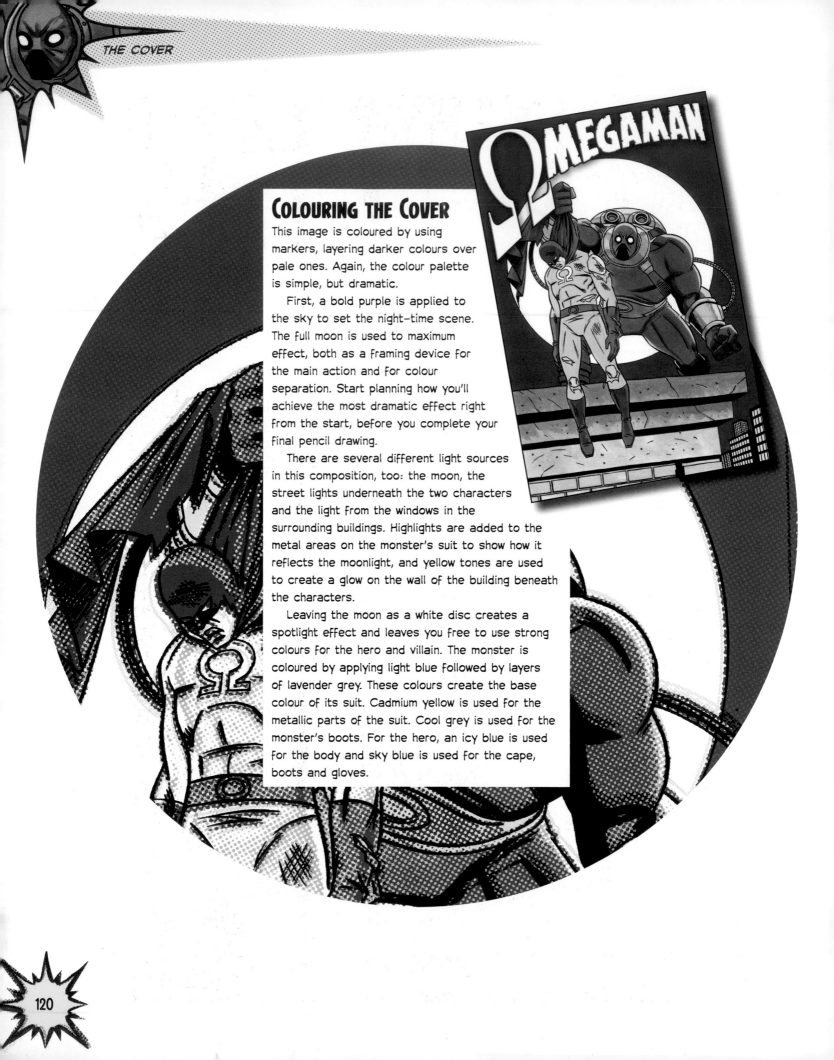

COLOURING THE COVER

This image is coloured by using markers, layering darker colours over pale ones. Again, the colour palette is simple, but dramatic.

First, a bold purple is applied to the sky to set the night-time scene. The full moon is used to maximum effect, both as a framing device for the main action and for colour separation. Start planning how you'll achieve the most dramatic effect right from the start, before you complete your final pencil drawing.

There are several different light sources in this composition, too: the moon, the street lights underneath the two characters and the light from the windows in the surrounding buildings. Highlights are added to the metal areas on the monster's suit to show how it reflects the moonlight, and yellow tones are used to create a glow on the wall of the building beneath the characters.

Leaving the moon as a white disc creates a spotlight effect and leaves you free to use strong colours for the hero and villain. The monster is coloured by applying light blue followed by layers of lavender grey. These colours create the base colour of its suit. Cadmium yellow is used for the metallic parts of the suit. Cool grey is used for the monster's boots. For the hero, an icy blue is used for the body and sky blue is used for the cape, boots and gloves.

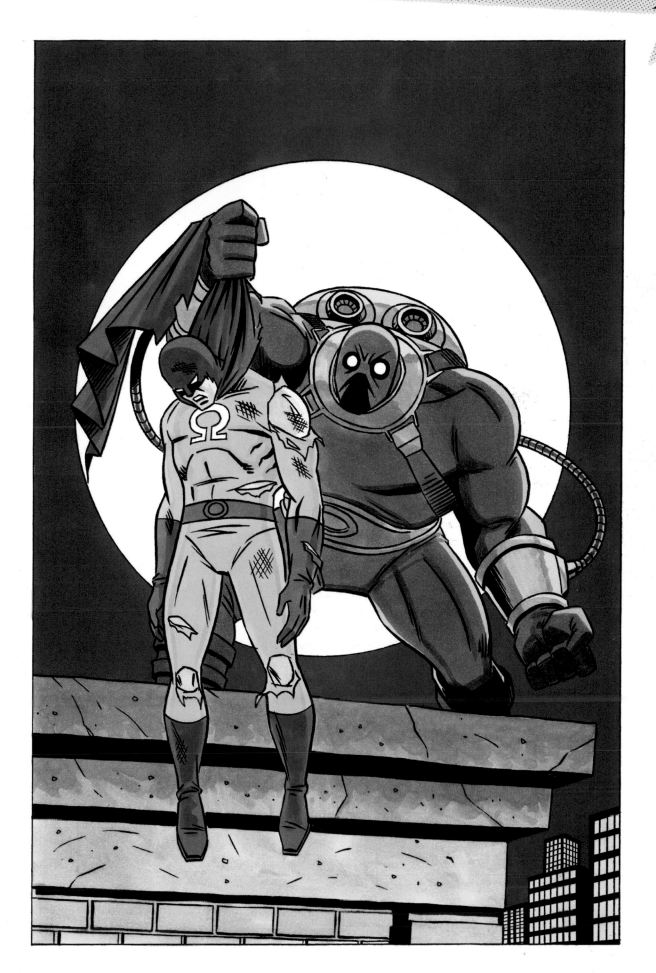

THE TEASER COVER

The teaser cover is used in a similar way to the story cover, to give the reader a taste of what to expect within the pages of the comic book. The difference here is that the teaser intentionally leaves out some information so the reader must fill in the gaps using his or her own imagination.

In our example, the hero is about to go into battle with a mysterious opponent. The villain is deliberately cast in shadow to create a bit of mystery. Readers might be able to figure out the identity of the villain by looking closely at the details on his outfit, but they'll have to work a little harder than if they were looking at a hero or a story cover.

The background is left plain, so the reader has no clues about the time frame of the event, its location, or who will win in the end. The focus is purely on the two characters and their confrontation.

On the right are some thumbnail designs for our teaser cover and on the facing page is the final pencil drawing of the chosen cover. The final cover may be simple in terms of the amount of detail shown, but the perspective makes it intriguing and exciting.

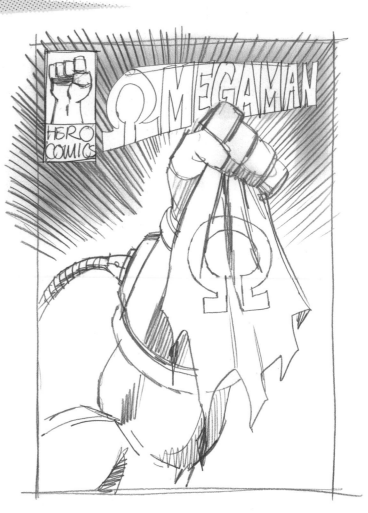

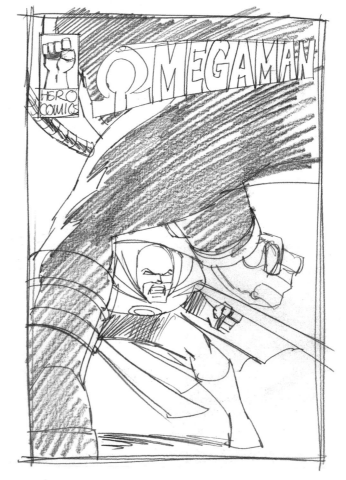

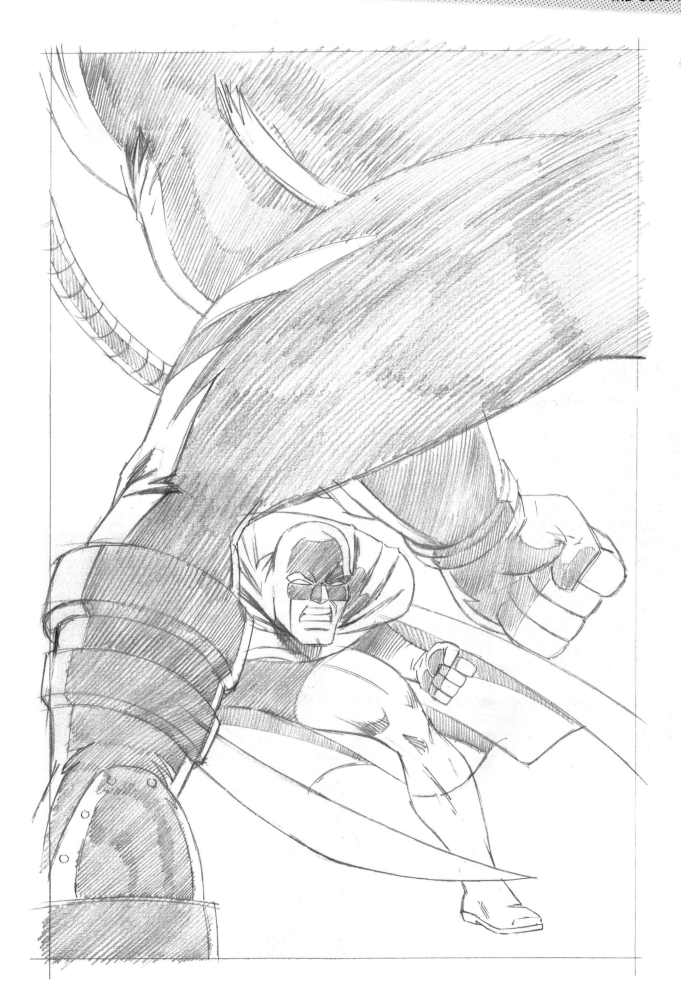

Colouring the Cover

As this is a simple composition with a lot of heavily inked areas, the colour palette must be carefully chosen to produce the most exciting effect.

We have chosen to use a bright attention-grabbing red background for our teaser cover, which will contrast brilliantly with the black ink. Also, as we're not showing any detail in the background, we can choose a colour that's symbolic of the action. Red is often used to alert the reader to potential danger; it suggests violence and aggression – the perfect backdrop for the battle between our hero and villain.

As you design your cover artwork, keep asking yourself the following questions:

• Will your cover design grab the reader's attention so much that they won't be able to put the comic book down?

• Have you left enough space in which to add the type?

• Do your colours work together and do they reflect the message you want to communicate?

If the answer to all these questions is 'Yes!' then you're on your way to creating a fantastic cover. Good luck and have fun!

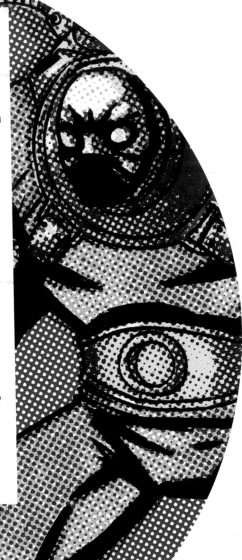

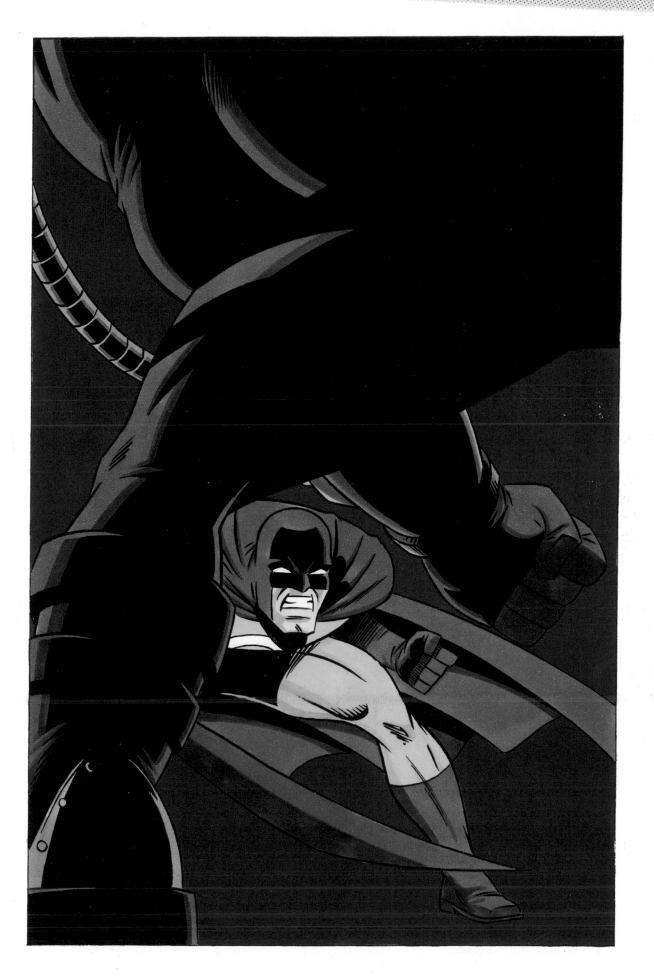